BASIC TECHNIQUES & EXERCISES

BASIC TECHNIQUES & EXERCISES
Painting Landscapes and Still Lifes in Watercolor

José M. Parramón

WATSON-GUPTILL PUBLICATIONS/NEW YORK

This edition first published in the United States in 1998
by Watson-Guptill Publications, a division of
BPI Communications, Inc., 1515 Broadway,
New York, New York 10036
Translated from the Spanish by Elsa Haas
Edited by Robbie Capp

Original Spanish edition
Editor: José M. Parramón
Text: José M. Parramón and Gabriel Martín
Production, layout, and dummy: Ediciones Lema, S.L.
Cover: Award
Photochromes and phototypesetting: Adrià e Hijos, S.L.
Copyright José M. Parramón
Copyrights exclusive of production: Ediciones Lema, S.L.

Library of Congress Cataloging-in-Publication Data

Parramón, José María.
 [Pintando a la acuarela paisajes, interiores y bodegones. English.]
 Painting landscapes and still lifes in watercolor ; basic
techniques and exercises / José M. Parramón : [translated from the Spanish
by Elsa Haas].
 p. cm.
 ISBN 0-8230-5129-3
 1. Landscape painting—Technique. 2. Still-life painting—
Technique. 3. Watercolor painting—Technique. I. Title.
ND2240.P37613 1999
751.42'2—dc21 98-30026
 CIP

Printed in Spain
1 2 3 4 5 6 7 / 04 03 02 01 00 99 98

Table of Contents

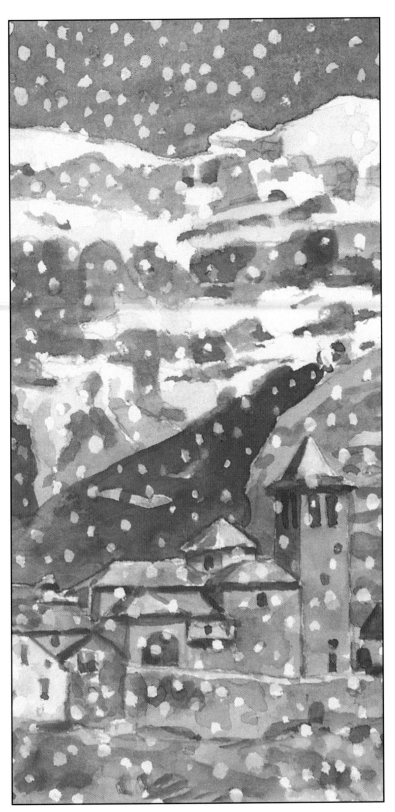

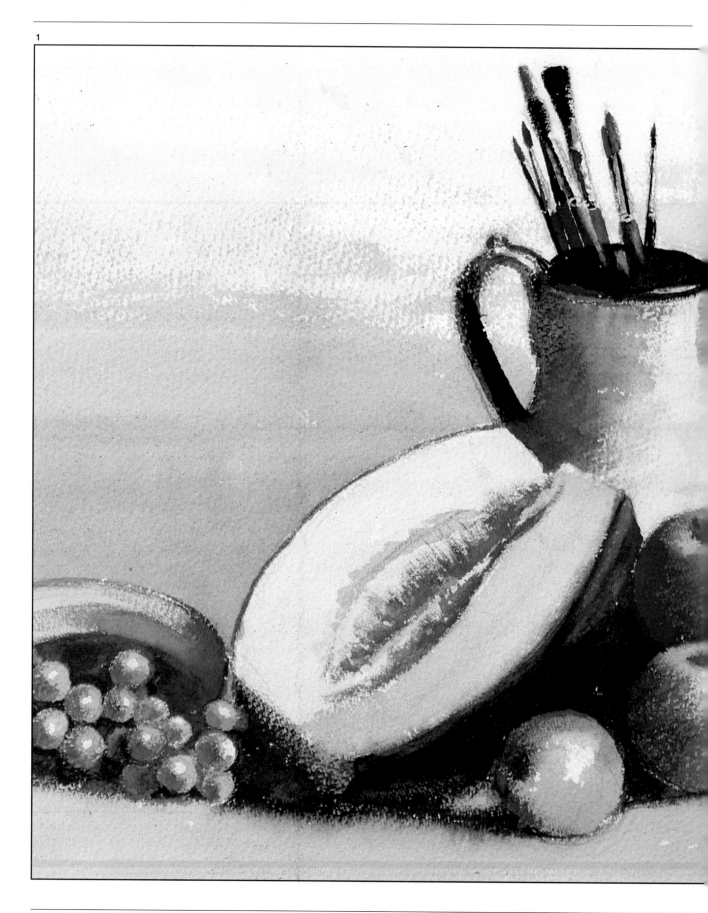

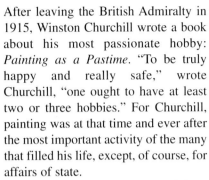

Fig. 1. By José M. Parramón, this painting from the artist's collection is the basis of an exercise in drybrush technique on pages 58 to 61, where you'll find a step-by-step demonstration covering two variations on the drybrush technique. Despite its name, one drybrush method entails using a brush filled with paint and water, applied here mainly in the background. After moisture is removed from the bristles, the other technique is rubbing the brush against the paper grain to produce the textured effects shown.

After leaving the British Admiralty in 1915, Winston Churchill wrote a book about his most passionate hobby: *Painting as a Pastime.* "To be truly happy and really safe," wrote Churchill, "one ought to have at least two or three hobbies." For Churchill, painting was at that time and ever after the most important activity of the many that filled his life, except, of course, for affairs of state.

The great future Prime Minister Churchill discovered painting at a time when his early career was at a standstill. One day his gaze fell on his children's paintbox, and it was then, at the age of forty, that he decided for the first time to try his hand at art. He continued painting, quite successfully, until the end of his days, and he wrote his book about painting to encourage others, describing the hobby as "an astonishing and enriching experience. I should be glad if these lines induced others to try."

If you've already started to paint a little in your spare time, this book will broaden your familiarity with the materials used in watercolor painting and will guide you in practicing watercolor techniques, such as wetting the paper first and then painting on it; drawing with a utility knife on dry paper; reserving white spaces with the use of glue; and other fascinating tricks. You'll be able to put these techniques to use in painting landscapes, still lifes, and interior settings. Included are tips on how to block in and compose a painting, establish its correct proportions, perspective, contrasts between light and dark values, and more. The book also includes some practice sheets of paper, so you can get started right away on the exercises described.

The all-consuming passion that Churchill had for painting has been felt by many others who have written about it. One of the greatest artists of all time, Vincent Van Gogh, said in one of his numerous letters to his brother

Fig. 2. José M. Parramón has written more than forty books on art instruction, which have been translated into many languages and published in countries on three continents.

Theo, "It is the excitement of creation that guides my hand, the excitement of working without even noticing that you are. And when at times you see how the brushstrokes emerge and intertwine like the words in a conversation, at those times the excitement is so strong that it can't be compared to anything else."

Van Gogh's biographer Rainer Metzer writes, "Every morning at six he left the yellow house in Arles, loaded down with his easel, box of paints, and stool. And he wandered without a break, looking for the motifs which might satisfy his creative zeal."

I hope that as you work with this book, you, too, will soon feel the excitement and fulfillment that watercolor painting can bring to your life.

José M. Parramón

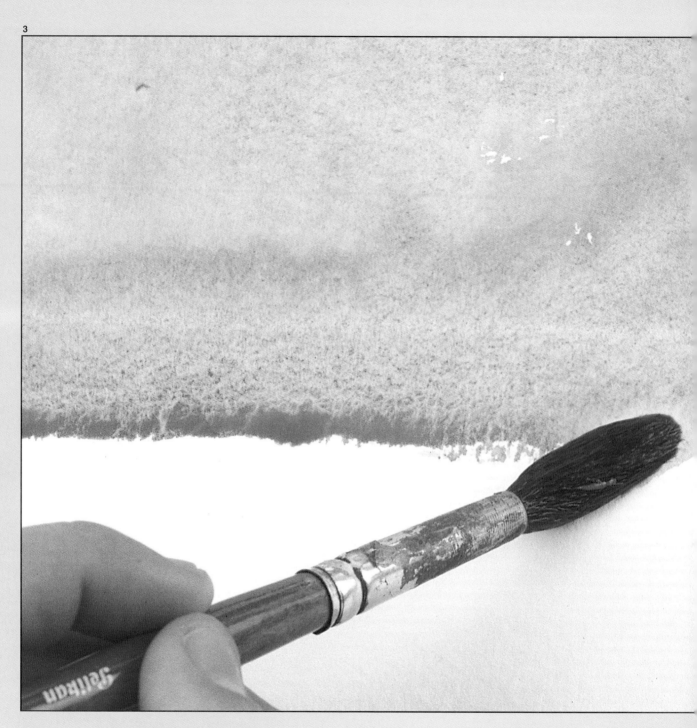

Fig. 3. In the first part of this book, one of the techniques described is how to paint backgrounds with a relatively dry brush, a useful method for landscapes. In addition to this technique, you'll find many other methods that enhance watercolor paintings, including opening up white spaces on areas that have already been painted by using the handle of a brush, a utility knife, and other fascinating tricks.

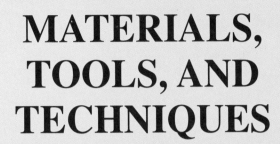

MATERIALS, TOOLS, AND TECHNIQUES

Aside from certain knowledge and skills, a good watercolorist needs specific materials in order to derive the most from the medium. If you're a beginner, the following chapters and many illustrations will provide you with a good foundation for getting started with watercolors. While top-quality materials used by professionals are expensive, student-grade paints and brushes are more reasonably priced, often of good quality, and quite suitable for beginner work. As you progress, you may wish to try certain more expensive watercolor paints, brushes, and papers.

If you're a more experienced painter already familiar with watercolor materials and their basic characteristics, these pages will help you to compare the range of colors and kinds of brushes and papers you usually use with those I'm suggesting, so that you can make more informed choices.

Forms of Paint and Color Range

Watercolor paints are made of pigments of animal, vegetable, or mineral origin that are mixed together and bound with water and gum arabic, along with glycerine, honey, and a preservative.

Watercolors are generally sold in three forms:

Pans of dry paint are difficult to use; in order to get color out of them, you have to scrub the pan repeatedly with the brush. These paints are very cheap, and generally best reserved for children's use.

Pans of semimoist paint (and half pans) are of high quality, made with a larger percentage of glycerine and honey, making them wetter than dry pans. Sets of pan watercolor come in various sizes in metal or plastic boxes that have built-in palettes for mixing colors. They can be very compact and portable, and are therefore the form often used by traveling or outdoor painters.

Tube watercolors, the form preferred by most professionals and other serious watercolorists, can be bought individually or in sets. The tubes come in different sizes, the most usual being the 5 ml (.17 fl. oz), 14 ml (.4/ fl. oz.), and sometimes 37 ml (1.25 fl. oz.), a large, studio-size tube. The tubes contain a creamy, fluid paint that is easily squeezed onto the palette. When mixed with water, tube colors are less intense; for more transparent effects and pale washes, the paint is further diluted with water.

Of the scores of colors available in tube form, a basic, very serviceable watercolor palette may include just these fourteen hues:

1. Lemon yellow
2. Dark yellow
3. Yellow ochre
4. Burnt umber
5. Sepia
6. Cadmium red
7. Alizarin crimson
8. Permanent green
9. Emerald green
10. Cobalt blue
11. Ultramarine blue
12. Prussian blue
13. Payne's gray
14. Ivory black

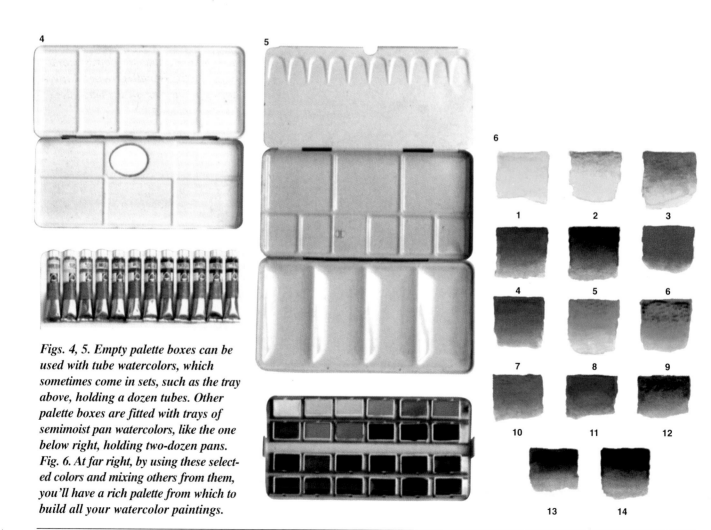

Figs. 4, 5. Empty palette boxes can be used with tube watercolors, which sometimes come in sets, such as the tray above, holding a dozen tubes. Other palette boxes are fitted with trays of semimoist pan watercolors, like the one below right, holding two-dozen pans. Fig. 6. At far right, by using these selected colors and mixing others from them, you'll have a rich palette from which to build all your watercolor paintings.

Palettes

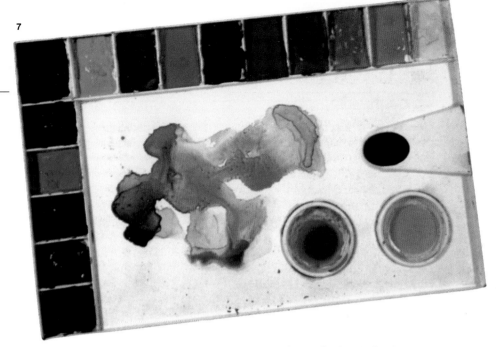

Watercolor palettes are usually made of rigid white plastic or of metal coated with a layer of white enamel; there are also less durable, disposable plastic palettes. The kind preferred by serious painters is rigid plastic with small square compartments that the artist fills with colors squeezed from tube watercolors. The rest of the palette provides a large area for mixing colors.

Pan watercolors usually come in sets that have their own built-in palette for mixing colors. So which palette is best for you? Obviously, the kind of palette you use depends on the form of paint you choose. Ideally, it's practical to have a set of semimoist pan colors with its own built-in palette for painting on location. But for studio painting, even if the studio is your kitchen table, a large palette with lots of mixing area and separate box compartments for holding fifteen to twenty colors squeezed from tubes is the thing to have.

Fig. 7. This is the kind of palette used by most professional painters, who fill the compartments around the edge with paint squeezed from tube watercolors. If the pigment dries between painting sessions, adding water revitalizes it instantly. The rest of the palette is used for mixing and blending colors.

Fig. 8. Some pan watercolor sets have a built-in palette with a thumb hole to make handling easier. Others have a metal ring on the back, used for the same purpose.

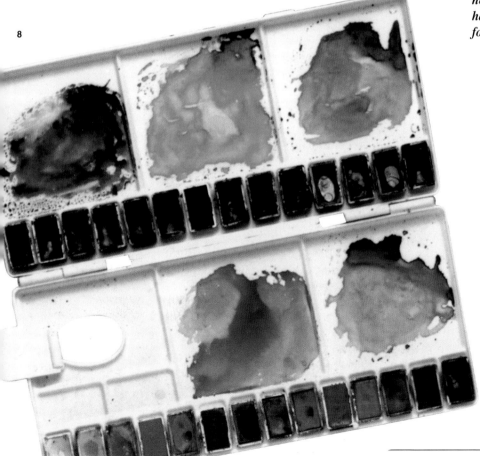

Easels, Supports, and Paper

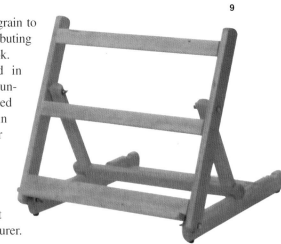

A watercolor easel shaped like a lectern is very practical for holding either a support board with your paper mounted on it or a block of watercolor paper. The compact size of this type easel allows it to be placed on a table so that you can paint sitting down.

A watercolor board to support paper is usually made of lightweight wood and comes in different sizes, the two most popular being 16 x 20" (41 x 51 cm) and 23 x 31" (58 x 79 cm), each made to accommodate certain standard-size sheets of watercolor paper, which are detailed below.

The look of a watercolor painting depends largely on the quality of the paper used, that is, on its thickness and its tooth, or grain--the degree of coarseness. The best brands of paper can be recognized by a watermark with the name of the manufacturer in one corner of the sheet. You can see the watermark by holding the sheet up to a bright light. The thickness of the paper is one way to determine its quality, since a thin sheet of drawing paper can't stand up to the wetness involved in watercolor painting; it just gets wrinkled and buckles. Paper thickness is described by the weight of a ream, expressed in pounds. The best-quality watercolor paper ranges from 90 lb., the lightest, to 555 lb., the heaviest. For most watercolor work that you'll be doing, 140 lb. paper is a good choice.

As for the tooth, or grain, of the paper, the three textures most commonly stocked by stores are referred to as hot-pressed, cold-pressed, and rough texture.

Hot-pressed paper has a smooth grain and is best used for pencil or ink drawings. With watercolor, it dries very quickly and is suitable only for small sketches or studies. Hot-pressed paper isn't an advisable choice for beginners.

Cold-pressed paper, which has a medium grain, is recommended for beginners, since it allows you greater control over the paint. It's also the choice of many professional artists who work in the watercolor medium.

Rough paper is the kind preferred by artists who want a lot of the grain to show up in their work, contributing significantly to its textured look.

Watercolor paper is sold in stock sizes that vary from country to country. In the United States, it is widely available in individual sheets, watercolor blocks (sheets mounted on cardboard in blocks of about twenty sheets glued on the edges), spiral-bound pads, and rolls. Sizes may differ a bit depending upon the manufacturer.

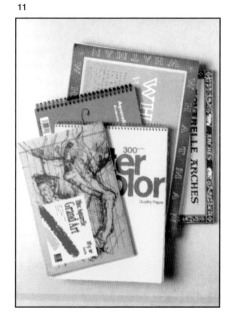

Fig. 9. A tabletop easel is useful for watercolor painting.
Figs. 10a, 10b, 10c. Observe the difference when the same wash is painted on hot-pressed paper, left; cold-pressed paper, center; and rough paper, right.
Fig. 11. Watercolor paper comes in blocks of a few sizes, with sheets glued around the edges to protect and keep them stretched, and in spiral-bound books of various sizes.

Brushes and Associated Supplies

A paintbrush consists of an enameled wooden handle fitted with a metal ferrule that grips the brush bristles. The quality of the bristles determines the quality of the brush itself.

The many different kinds of water-color brushes on the market today fall into two broad categories: natural or synthetic.

Natural brushes are made of several different types of animal hairs; among them, the *sable brush* is best for watercolor painting. The bristles come from the tail of a small rodent, the Siberian kolinsky sable. The brush has the capacity to pick up a lot of water and paint, be flattened or fanned out, and then be reshaped into a perfect point—characteristics that are important in handling watercolors. Other animal hairs used include squirrel, ox (also called sabeline), and goat, but none have the combination of resiliency, good water retention, and ability to hold a fine point that the sable brush offers.

Synthetic brushes appeared on the scene relatively recently and are much less expensive than sable brushes. A large, flat synthetic brush is just as good for wide washes as a sable brush, and many other sizes and shapes of brushes with synthetic bristles also serve watercolorists well.

As for sizes, sable watercolor brushes come in different thicknesses, categorized by number: #000 for the thinnest to #24 for the thickest, and in various shapes. From out of the wide selection available, I would recommend that you stock: three sable brushes, #5, #8, and #12; a synthetic #8 brush; two flat brushes—a sable #14 and a synthetic #18.

To use and care for your brushes properly, when painting indoors, have the right kind of water containers at hand: a wide-mouthed glass jar that can hold at least a pint of clean water for wetting your paper and/or dipping your brushes, and at least one other large container to hold the water that will get progressively dirtier each time you rinse your brushes as you work. To serve your needs when painting outdoors, instead of breakable glass, take along at least two plastic containers.

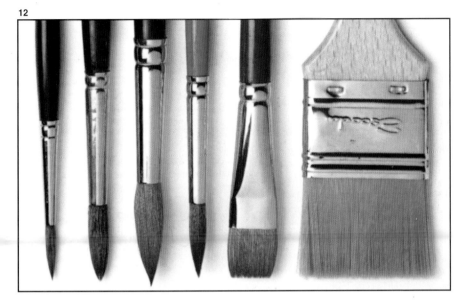

12

Fig. 12. The basic selection of water-color brushes should range from a thin one for detail work to a very broad brush for applying overall washes, and in-between sizes for most other work.
Fig. 13. Keep containers on hand for washing brushes, and always store them vertically, bristles pointing up. Glass containers should remain in the studio; use plastic for outdoor painting and travel.
Fig. 14. Rulers, clips, tape, erasers, rags, and paper towels are always useful to the watercolorist.

13

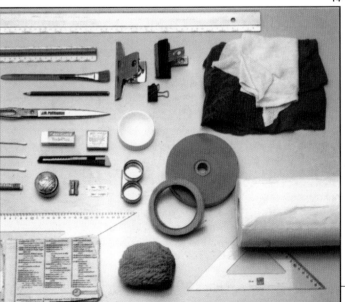

14

Painting Backgrounds on Dry or Wet Paper

Light wash on dry paper: To practice applying a light, even wash on dry paper, begin by taping a sheet of watercolor paper to a support board. With a pencil, lightly rule off a rectangle measuring about 4 x 6" (11 x 16 cm).

Put a good amount of cadmium red or alizarin crimson on your palette. Using a #12 brush, paint an inch-wide band of light wash across the top of your rectangle. Try to match the tonal value shown at right (fig. 15). Work quickly to keep the wash good and wet.

Now direct the wash downward (fig. 16), using vertical brushstrokes. The more you tilt the board, the more your color will accumulate in the lower part of the wash. If too much accumulates, adjust the position of your board.

When you reach the lowest part of your ruled-off area, there will probably be excess liquid at the bottom. Dry your brush and then absorb the excess liquid on it (fig. 17).

Applying a smooth and even wash depends on three factors: the quality of your paper; the position of your board; and the amount of water and paint on your brush. Unfortunately, if you make a mistake, there's no way to touch it up; your only option is to start over again. Just be patient and I assure you, practice will get you there.

15

16

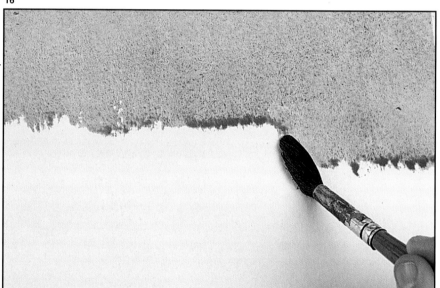

17

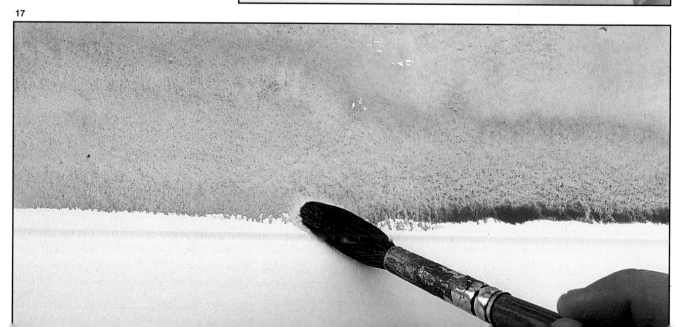

Washes of different tones on dry paper: This exercise shows how to paint four different tones of one color, in this case, cobalt blue, ranging from dark to light (fig. 18).

Lightly pencil in a rectangle, about 2 x 7" (5 x 18 cm) for each tone. Starting with the darkest tone, load your #12 brush with a saturated mix of cobalt blue. Try the mixture on test paper. When you get a shade that looks like the one shown here, spread the color evenly until it fills the whole rectangle. Make sure your paper stays wet enough to prevent breaks or changes in tone.

Clean and dry your brush. You'll be repeating the same procedure for the other three rectangles, but progressively reducing the amount of color and increasing the amount of water in each mix.

For each wash, your objective is twofold: to match the tone in the examples shown, and to keep the color evenly spread. Here's a final tip to help you reach those goals: In deciding how much water to add to get each tone, keep in mind that it's always safer to use too much than too little.

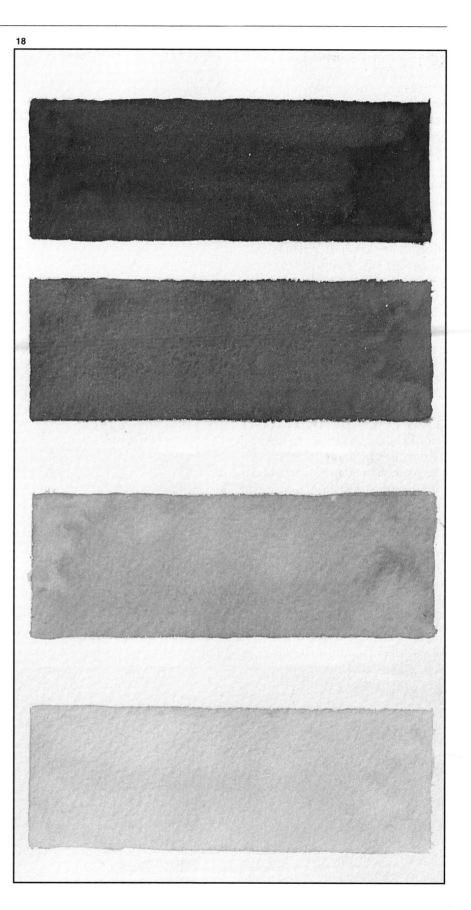

18

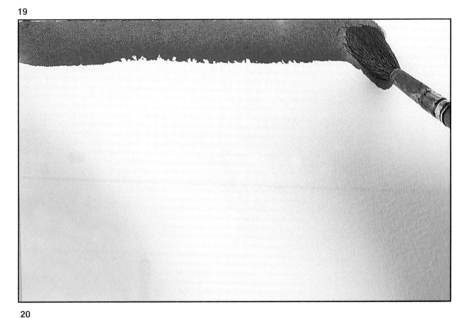

Value scale on dry paper: Lightly pencil in a 3 x 6" (11 x 16 cm) area on a practice sheet of paper. This time you'll be creating a value scale that moves gradually from dark to light in tones of raw sienna. Before you start, remember to have test paper on hand.

The success of this exercise will depend in great measure on the amount of water your brush is holding when you begin to paint. Start by applying a horizontal band saturated with color (fig. 19); work quickly. Wash the brush, wiping it on the edge of your water jar, then pass the wet brush over the bottom half of the band you've just painted, thus diluting it (fig. 20). Always use horizontal strokes, working from the top of the rectangle to the bottom. The idea is to put some pressure on the brush so it gradually releases the water it contains; the water will remove some of the paint from the paper, from top to bottom, thus producing a subtly blended value scale.

After washing the brush again, keep diluting the paint with the brush until you get to the bottom of the rectangle (fig. 21). Load the brush with water, then wipe it on the edge of your water container, controlling the amount that remains on the brush. Now retouch the lowest part of the wash, being sure never to go back toward the top of the rectangle, since that could produce spots or abrupt changes in tone, ruining the gradation effect.

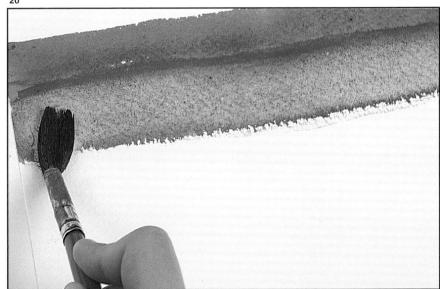

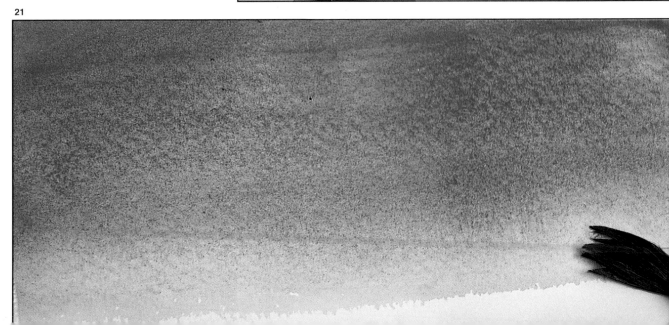

Value scale on wet paper: Watercolor painting on wet paper produces effects that differ from painting on dry paper, as this exercise will show. Work with the #12 brush that you used in the previous exercises, and you'll also need a small sponge. Start out by wetting the sponge with clean water and passing it lightly over your paper until the whole surface is wet. Don't press on the paper; that will damage its surface fibers.

When the paper has absorbed part of the moisture, load your brush with emerald green, using less water than when working on dry paper. Paint the top of the sheet, spreading the color with rapid strokes (fig. 22). The most critical area is from the top down to the halfway point. It's a question of trial and error. You may have to alternately wet the paper and absorb some of the moisture, until a subtle, graduated value scale is achieved. Don't be surprised if it doesn't turn out exactly right the first time.

To paint with a sponge, submerge a sponge in clean water and, after wringing it out a little, wet the surface of the paper with several horizontal strokes, working from top to bottom (fig. 23).

On a palette or in a shallow bowl, prepare a wash of yellow ochre with a little raw sienna added. Wring the sponge out again, then use it to soak up some of the ochre blend, and repeat the previous step but press down lightly on the sponge as you move it across the paper, varying the pressure as needed to get the color you want (fig. 24). Once you've covered about two-thirds of the sheet, wring out the sponge and add clean water to get a light wash for completing the exercise (fig. 25).

The last step is to retouch the lower portion and make it uniform. If necessary, absorb any excess water with a brush (fig. 26).

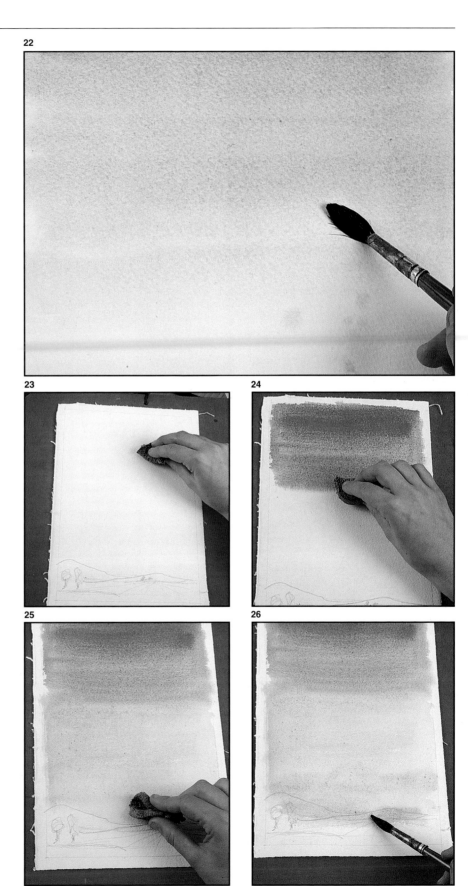

Watercolor Techniques

Now let's explore various watercolor techniques, beginning with several different ways to brighten a painting by opening up white areas.

Of course, the first way is to leave parts of the paper unpainted altogether; paper white is the whitest part of a painting. But sometimes you'll want to remove paint that's been applied and whiten that area; that's what these techniques demonstrate.

Opening white spaces on a wet wash: Start by washing and drying the brush to be used. On a uniform wash that is still wet (fig. 27), work your dry brush over a patch of the surface and see how it absorbs color and opens up a white space (fig. 28). If you master this technique, you'll find it useful for whiting out clouds, for example, to contrast against a blue sky.

Opening white spaces on a dry wash: Now try producing the same effect on a wash that's already dry. Using a synthetic brush, deposit a generous amount of clean water on the area to be opened up (fig. 29). After waiting a few moments for the water to soften the wash, lightly rub your paper with the brush tip until color is diluted and released (fig. 30). If you still haven't managed to open up a white space, you can try again, using a solution of water with a few drops of bleach added to it.

Reserving white space by masking it: Once you've made a preliminary drawing of your subject, with a #4 synthetic brush, apply rubber cement or frisket (a masking fluid somewhat like glue) in areas that you want to reserve as white in your painting (fig. 31); immediately wash the brush with soap and water. Known as the resist technique, masking areas that remain white enables you to paint colored areas (the green leaves in our example) without getting paint on masked areas, because glue repels water (fig. 32).

Once the painting is finished and dry, remove the frisket or rubber cement by peeling it off, exposing the white paper (fig. 33). Now we leave the daisy

petals paper white and color their centers yellow, adding shadows and highlights (fig. 34).

Frisket can be a big help but it shouldn't be overused to the exclusion of other techniques, such as opening up white space using a wet brush.

Figs. 27–34. Techniques used for opening up white spaces on a wet wash (figs. 27, 28); on a dry wash (figs. 29, 30): and for reserving blank spaces with frisket or rubber cement (figs. 31–34).

27

20

29

30
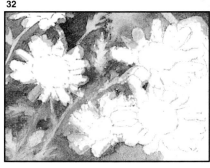

31
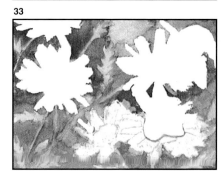

32

33

34

Reserving white space with wax: Once you've made your drawing, choose the white spaces you want to reserve. Cover those areas with a film of white candle wax, using thin strokes (fig. 35). Next, use your watercolor paints as you normally would, knowing that you can paint on top of the wax without the paint hitting the paper, since the wax will repel it (fig. 36). However, don't paint repeatedly over the wax, since it could eventually absorb part of the color in the wash and then the white spaces would be ruined.

Opening white space on dry paper with a synthetic brush: Using a #4 or #5 synthetic brush, wet an area of your paper with a generous amount of clean water. Let the water sit there for a few minutes, then gently rub with a clean, moist brush until the color released from the paint darkens the water. By drying the puddle of water with a piece of paper towel, you will cause a white space to appear on the paper (fig. 37). Once that area has dried, you can start painting again (fig. 38).

Opening white spaces with a brush handle: Use this technique on a dark area when a painting is still wet (fig. 39). To open up white spaces here, rub the beveled handle of a brush on the paper surface. A similar method is scraping the paper with a fingernail to create thin white lines (fig. 40).

Opening up white spaces with sandpaper: Start by painting your subject in the usual way, or try the example shown, a rocky riverbank (fig. 41). After the painting has dried completely, using either fine or semi-coarse sandpaper (depending on the grain of paper you've painted on), open up white spaces by vigorously rubbing selected areas (fig. 42). I recommend that you use a thick, high-quality paper with good fiber content for this exercise.

35

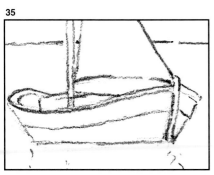

36

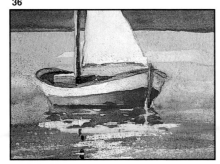

37

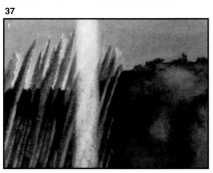

38

39

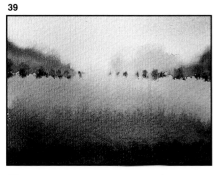

40

41

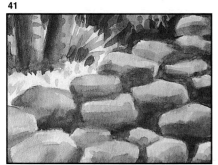

42

Figs. 35–42. Whether you reserve white spaces with wax (figs. 35, 36) or open them up on a dry painting using a wet paintbrush (figs. 37, 38), the handle of a brush (figs. 39, 40), or sandpaper (figs. 41, 42), the result is bound to enhance your work.

Drybrush technique: This method is based on painting with a brush loaded with color but almost no water. Rubbing the brush over a rough-textured drawing paper will result in the effect shown (figs. 43 and 44).

Creating textures with water: After painting with watercolors on wet paper, apply a brush loaded with very clean water to the area you've just painted, while it's still wet. You'll get surprising textural effects that will enrich the quality of your work (fig. 46). The same technique can be used with oil of turpentine, producing similar results.

Trying out shades and colors: As painter Maria Fortuny's example shows (fig. 48), when painting with watercolors, it's a good idea to leave a margin of an inch or two at one edge of your paper, so you can experiment with colors and mixes before commiting them to your painting.

Creating textures with salt: You can obtain unusual textural effects by sprinkling salt (preferably coarse salt) on a color wash that is still wet (fig. 49). The salt technique enhances backgrounds, walls, mountains, skies (fig. 50), and other subject matter. Once you have the effect you want and the wash has dried, rub it gently with your hand to remove any grains of salt that are stuck to the painting.

Figs. 43–50. These images illustrate various techniques for producing interesting effects and textures.

43

44

45

46

47

48

49

50

Value scales using splattering: To darken a sky (fig. 51) or almost any background that needs intensifying, try this technique. Rub a toothbrush loaded with color over the teeth of a comb (fig. 52). The spatter produced (fig. 53), though very subtle, brings new vitality to the painting, don't you agree?

But remember, when employing this technique you must cover all the parts of the painting that you don't want splattered so that none of the spray mist hits those areas.

Opening white spaces on a dry painting with a utility knife: Once a painting is completely dry, take a utility knife and rub it hard on selected areas, in this case the reflection of light on a boat's mooring (fig. 54). Be sure to do so with a single stroke, so that you don't make a hole in the paper or cause other damage to it.

Textural effects with turpentine: For this exercise you need a synthetic brush loaded with turpentine and applied to an area of the paper that is still wet (fig. 55). When the wash on the paper comes in contact with turpentine, you'll get light, irregular spots of color (fig. 56). Note that once an area has been touched with turpentine, you can paint on it again, although it's not a good idea to paint a lot in that area, since you might lose the very effect you were trying to achieve.

Splotches made with paper: Some appealing paintings, usually abstract ones, are made by putting a sheet of paper that has just been painted in contact with another sheet that is either blank or has also been painted (fig. 57). Pressure applied to the wet color can be a great way of finishing backgrounds or sky, mountains, foliage, etc., in an otherwise realistically painted landscape. The abstract example shown here (fig. 58) began with a spot of carmine painted on the surface of one sheet, then after a few minutes, it was pressed against a blank sheet, producing an intriguing image.

51

52
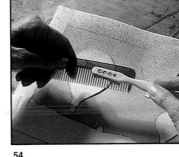

53
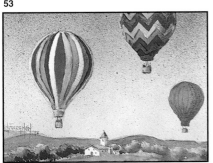

54
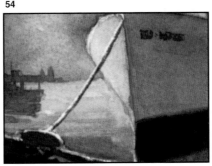

55
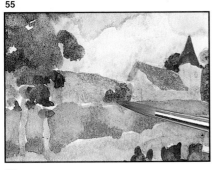

56

57

58

Figs. 51–58. A toothbrush and comb produce lively splattered effects; simple scraping and blotting tools offer other surprising results.

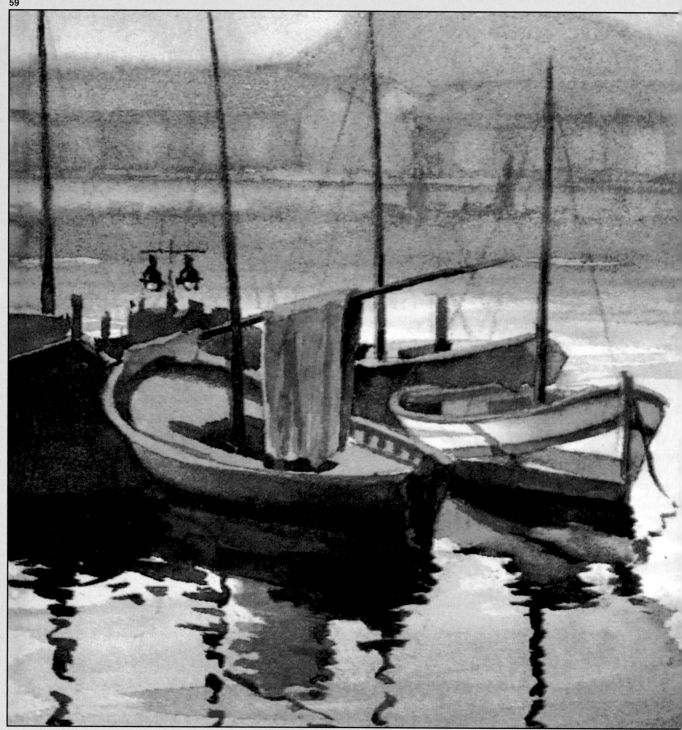

Fig. 59. This appealing subject matter depicts fishing boats at a wharf in Barcelona, illustrating the principles of painting contrast and atmosphere, as explained on pages 31–33.

DRAWING, PERSPECTIVE, COMPOSITION, AND INTERPRETATION

As you've already learned, watercolor painting encompasses a great variety of techniques, some of them unique to this medium, such as opening up white spaces on wet or dry paper, or using the beveled handle of a brush as a marking tool.

From here on, we'll be exploring other aspects of art that will be most useful to you in your development as a watercolorist, including preliminary drawing, creating volume and the third dimension, handling perspective, the art of composition, and selecting themes for your paintings—skills that will add immeasurably to your enjoyment of working with watercolors.

Themes: Landscapes, Interiors, Still Lifes

Watercolor painters often make sketches or quick studies that they set aside and use later as reference material for major works. I encourage you to sketch, using your paintbrush, on city streets, in the countryside, in parks, in your backyard, or anywhere inside your home. Draw the objects you see on top of your own kitchen table or the ones that catch your eye when you're riding on a train or plane or standing on a corner waiting for a bus. If you put time into amassing a large collection of sketches, you'll see how useful they can be to you. Some of those quick studies may eventually be transformed into finished artworks.

Watercolor is an ideal medium for the landscape painter. A small set of pan watercolors, with its own built-in palette, a small block of drawing paper, two or three brushes, a couple of rags, and a container of water—all of these things can fit into a shoulder bag and go with you wherever you're headed. Carrying this equipment will encourage you to examine all the nooks and crannies of your surroundings, searching out little flashes of color that will inspire you to choose a theme for it.

Your sketch should be just a first try, a watercolor that you'd be willing to throw out or rip up. With this attitude,

Fig. 60. The home is a great place to start doing quick studies, as this interior scene by Merche Gaspar illustrates.

60

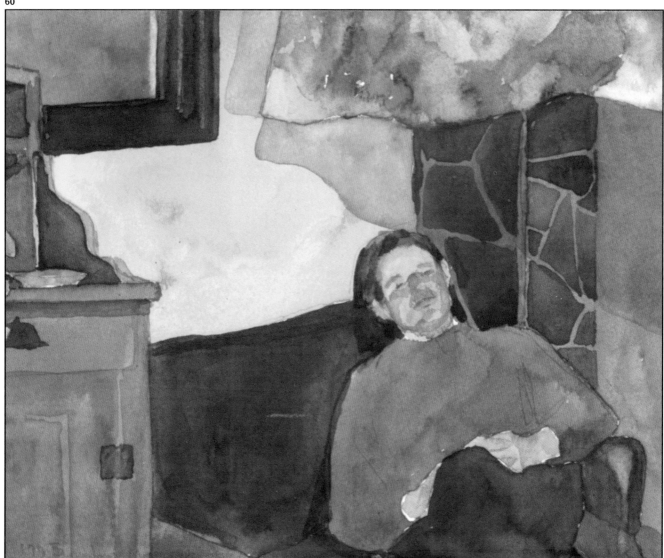

you can work more freely, knowing that you can always go back and start again.

The watercolors on these pages are good examples of landscapes, interiors, and still lifes to guide your lessons. They were painted by Merche Gaspar, a former student of fine arts who now teaches painting. In her work you can see the spontaneity that characterizes fine work in the watercolor medium.

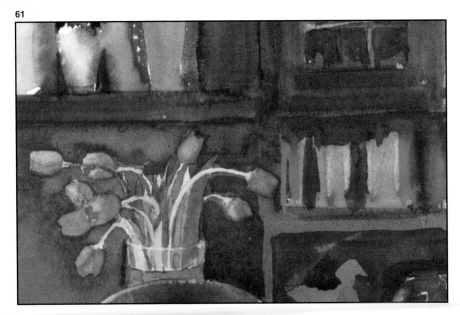

Fig. 61. From a comfortable position on the sofa of your own home, you can pick out whatever objects most appeal to you, such as this vase of red tulips on a nearby table.

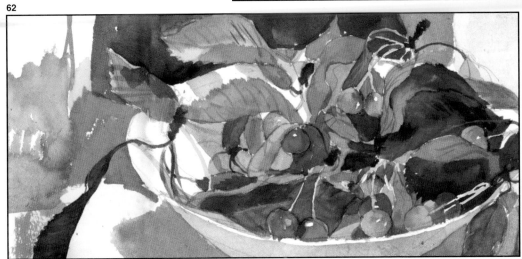

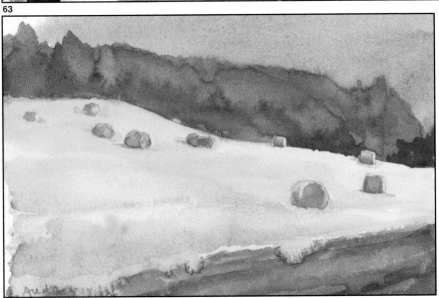

Fig. 62. Any subject has potential, as this bowl of greens and cherries in disarray show. On a small watercolor block, start painting colorful little vignettes that catch your eye.

Fig. 63. Marche Gaspar always takes a 4 x 6" (10 x 16 cm) block of paper along on summer vacations or even just for walks to enjoy the outdoors near home. Here's another sample of her work.

Drawing a Landscape to Scale

The subject on this spread is a country house nestled in an autumn landscape in the mountains of Montseny, about forty miles from Barcelona (fig. 64). As with all subject matter, dimensions and proportions drawn to proper scale should be calculated before you begin to sketch, and with landscapes particularly, estimating distances is important. The best way to calculate relative measurements is by holding up a pencil (fig. 67) to locate the center of the scene. In this case, it coincides with the point of a roof in the middle ground of the setting.

I begin as I do all my drawings by dividing my paper into four equal parts (fig. 65). This time I also divide the lower half into six sections (fig. 66), then I start sketching in the lower-left quadrant. I observed that the roof peak of the large house was located almost exactly at the level of my horizontal dividing line. I estimate the roof angle, then I eyeball the height of the large house and place the door and largest window each a third of the way along my horizontal line.

To draw in the furrows of the field in front of the house, I start at the edge of the green grass, near my vertical guideline. Estimating the curve of this border of green, I draw in the furrow farthest to the left, then mark the four points where

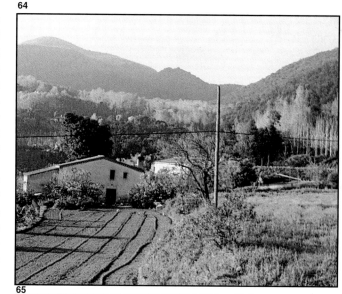

64

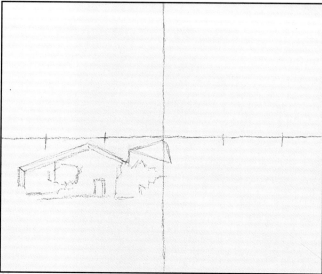

65

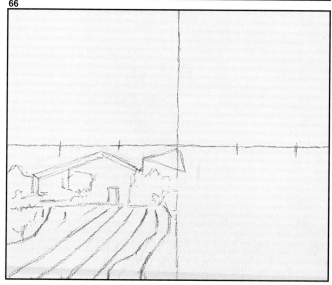

66

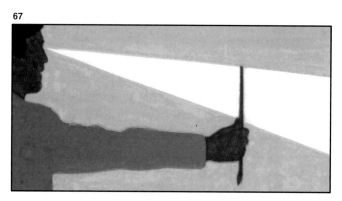

67

the other furrows end, then finish off the parallel or convergent lines formed by the furrows (fig. 66).

Preparing to block in the right-hand side of the foreground, first I held up my pencil and noticed that the telephone pole (which doesn't appear in the final drawing because I decided to leave it out) is located exactly in the middle of the first third of the lower right quadrant.

Using the pole as a reference point, I draw in the tree trunk (fig. 68) and some slightly sloping horizontal lines that form the darker triangle beyond the grass, then place the line marking where the grass ends, and other lines suggesting shapes off to the right.

After dividing my vertical line into four equal parts (fig. 69), I held up my pencil and saw that the lowest part of the mountain range's profile is about a quarter of the way down the sheet. I draw in this part of the mountain range first. With the vertical line as a guide, I judge the relative posi-

tion of the most distant mountain peaks and add their contours.

Finishing off the top right quadrant by drawing in the willow trees, I use the lowest point of the mountain range as a reference point for positioning the top of the tallest willow. Again just judging by eye, I draw in the lines that define the slight slope of the grassy area at lower right (fig. 69), then move back to the left to add the windows of the large house.

To finish my sketch, I block in background trees on the left (fig. 70), then add curves within this outline, using the shapes of the large house, the windows, and the tree on the left in front of the house as points of reference. Finally, I draw the large, almost rectangular stand of trees behind the house, estimating its proportions as related to the peak of the roof.

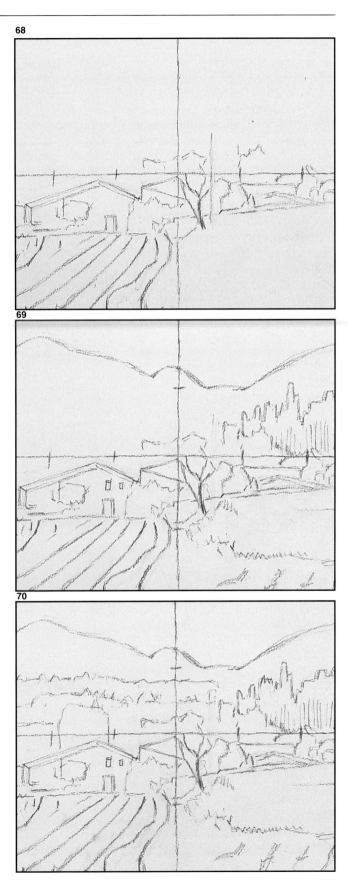

Figs. 64–67 (left) and 68–70 (right). Establishing a horizon line, then dividing your paper in quadrants, are essential first steps to aid in placing elements in correct scale and proportion to one another in a landscape composition.

The Basics of Perspective

Perspective plays an important role in depicting outdoor scenes, particularly those that encompass streets receding into the distance, buildings set at varying angles and planes, and other elements that are tricky to draw. Indoor settings as well, such as the one shown on this page, demand knowledge of perspective.

While this book won't attempt to cover the complex subject of perspective in detail, let's review some basics to guide you in drawing, then painting, many elements that you're bound to find interesting as subject matter: a group of houses, a road stretching into the distance, a row of trees, or various appealing interior settings.

If you're already familiar with some of the information presented here, reviewing it might just refresh your knowledge on some points. The first two basics are these:

The horizon line: This is the imaginary line where sky and earth meet (fig. 71). Standing on a beach and looking out to sea, the horizon line is at eye level. If you walk along a beach and then on seaside cliffs, you'll notice that the horizon line moves upward with you as you climb (fig. 72), and downward if you're on the shore at sea level (fig. 73).

Vanishing points: Located on the horizon, these points bring together a group of lines at an angle to the horizon line. If you look at these lines you'll see that there are two basic kinds of perspective: parallel perspective, from a single vanishing point; and oblique perspective, from two vanishing points.

Although we won't cover it since it isn't used in painting landscapes, it's interesting to note that there is a third kind of perspective: aerial perspective, or three-point perspective.

Observing the effects of parallel perspective with a single vanishing point as applied to an interior (fig. 74), it's most important to note that vertical lines are always straight up and down,

even when they appear to be coming closer together as they recede into space.

Figs. 71–73. The horizon line is always located at eye level. If we move up, it rises with us; if we move down, it falls.

Fig. 74. Parallel perspective, with a single vanishing point, applies to this interior.

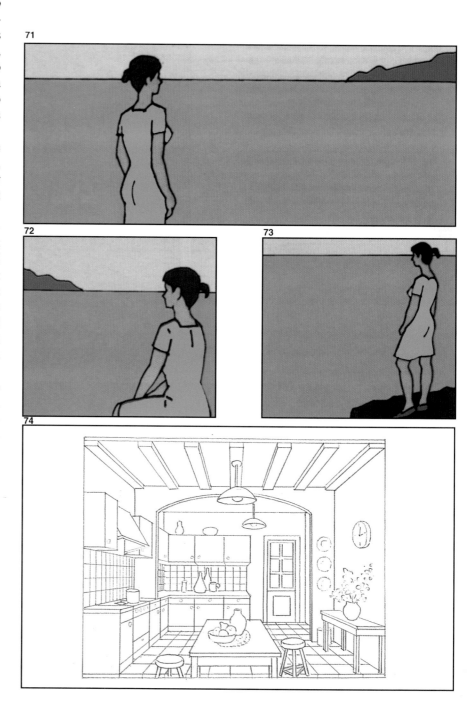

A room similar to the one on the previous page is shown here, but this time in oblique perspective (fig. 75).

For an outdoor scene (fig. 76) where the distance between columns of this cloister must be kept in perspective, there are set guidelines to follow (figs. 77, 78, 79, and 80). This method allows you to divide a space in depth and in perspective, whether the space is the gothic cloister of an old monastery like the one shown, or an entirely different kind of space.

75

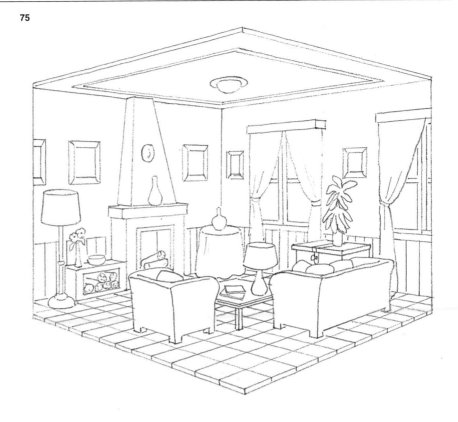

76

Fig. 75. Oblique perspective, with two vanishing points, applies to this interior.

Figs. 76–80. Guidelines help establish the division of space in depth and perspective.

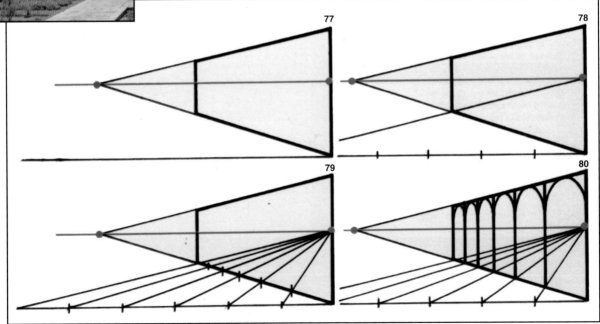

Typically, when you're painting a landscape, a street, a group of houses, or another expanse of subject matter and are working outdoors with only a watercolor block or other relatively small support for your paper, the vanishing points will fall outside of your drawing surface. To ensure rendering perspective accurately when you undertake this kind of drawing, or whenever you want to draw a scene in exact perspective, work with extended guidelines to establish points where shapes in perspective converge.

Referring to the figures below, when drawing a theme in perspective and the vanishing points end up outside the plane of your drawing paper, you can estimate the place where the lines come together with the eye alone by using other lines to guide you. Start by boxing in the subject, in this case, an interior seen in oblique perspective (fig. 81). First draw a vertical line (fig. 82), and from there the vanishing lines B and C, respectively, above and below the model.

Next, divide the vertical line A into a number of equal parts (fi. 83), seven in this case. Then draw another vertical

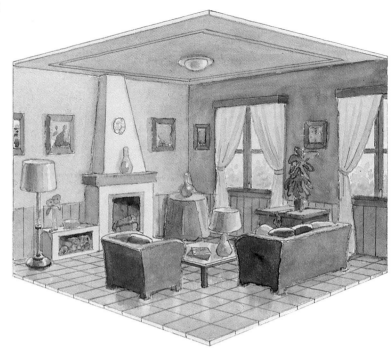

line in the left and right margins, outside the drawing, and divide each into the same number of parts as you did line A.

Last, use vanishing lines to unite the segments of the three vertical lines in order to obtain lines D, E, and F (fig. 84).

Fig. 81. This neutral palette is enlivened by the addition of colorful accents.

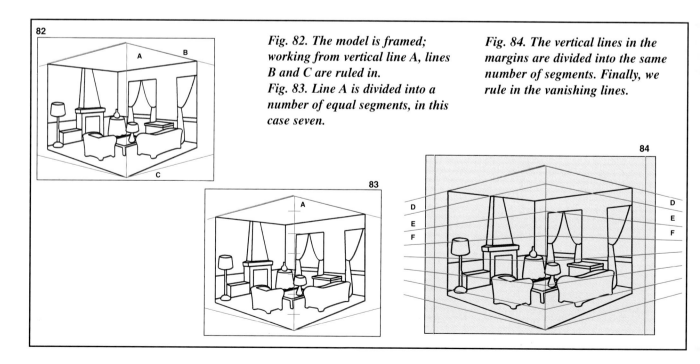

Fig. 82. The model is framed; working from vertical line A, lines B and C are ruled in.
Fig. 83. Line A is divided into a number of equal segments, in this case seven.

Fig. 84. The vertical lines in the margins are divided into the same number of segments. Finally, we rule in the vanishing lines.

Contrast and Atmosphere in Landscapes

Once you've drawn a theme in two dimensions, you can darken or lighten certain areas or accents to create contrasts that will express the effects of depth and distance, thereby suggesting a third dimension. The portrayal of the third dimension through the effects of light and shadow should be a primary objective in all of your watercolor paintings.

When we look at a nearby object, the eye focuses on it and automatically puts all surrounding objects that are not at the same distance from us out of focus. When you paint a landscape, still life, or other subject, you'll do the same sort of thing with your brush, by painting objects in the foreground with relative clarity and those that are farther back with less precision and definition.

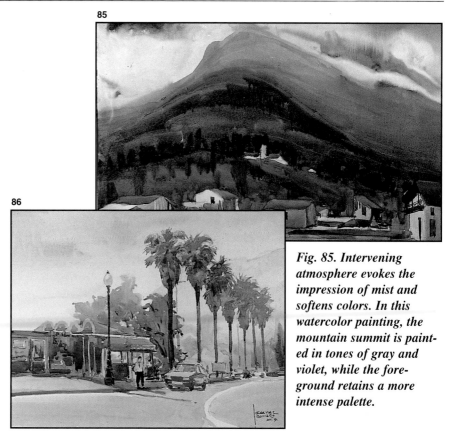

Fig. 85. Intervening atmosphere evokes the impression of mist and softens colors. In this watercolor painting, the mountain summit is painted in tones of gray and violet, while the foreground retains a more intense palette.

Fig. 86. Note how these palm trees become less disinct and lose some of their color as they recede into the distance.

Fig. 87. In this watercolor painting by Thomas Miles Richardson, Jr., distance is implied by the gradation of tones describing trees along the riverbank.

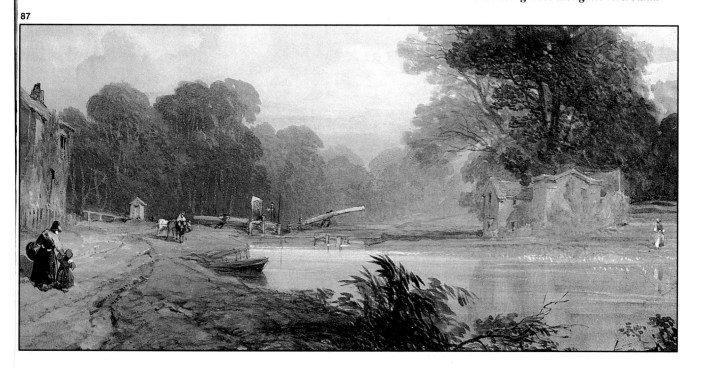

Composition Principles

After reflecting on the best format to use (horizontal, vertical, or square), we are faced with the question of how to organize the space within a picture. The art of composition involves putting shapes together and organizing the variety of elements that make up a subject in such a way that order and unity are created.

But just how should the elements be combined in order to achieve a visually satisfying whole? There is no magic formula for correct composition, but there are two guidelines that you may find very useful.

The first is known as Plato's Rule, which can be summed up in this brief maxim: "Find and show variation within the whole." Starting from a variety of shapes and their possible arrangement, location, and size, all the elements in the picture have to be organized in such a way that this variety yields a harmonious unity capable of awakening the interest of the viewer. Applying this rule, viewing the same objects shown in three different layouts (figs. 93, 94, and 95), which composition would you say meet's Plato's objective?

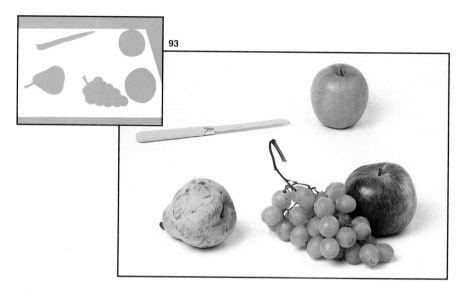

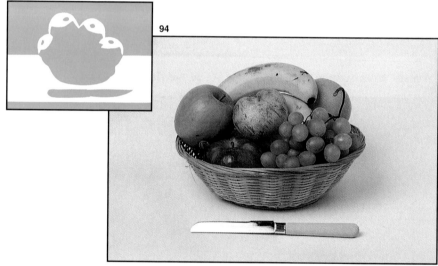

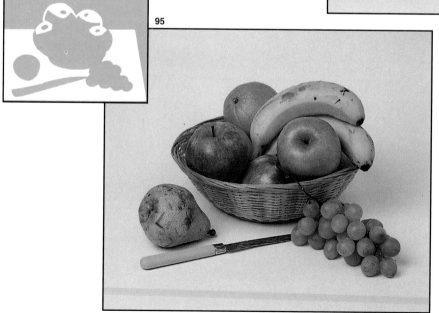

Figs. 93–95. By examining these figures in the light of Plato's "variety within unity" credo, the first example shows us how placing objects too far apart draws attention to individual items but fails as a cohesive painting. On the contrary, in the second example, there is too much unity, producing a tight, monotonous, and uninteresting still life. Finally, the third composition succeeds in offering both variety and unity, resulting in a handsome still life.

Another composition principle, known as the Golden Section, was devised by Euclid. It is an attempt to deduce what would be the ideal placement of the main motif within the plane of the work. The simplest solution, of course, might be to place the main element at the center of the picture. But the principle of the Golden Section allows the center to be slightly displaced to one side or the other in order to avoid monotony and symmetry. In defining that golden point Euclid said, "For a space divided into unequal parts to look pleasing and esthetic, the smaller part should be to the larger part as the larger is to the whole."

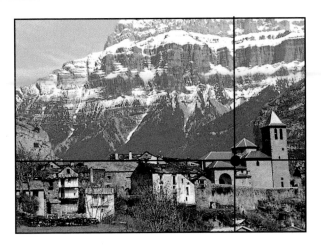
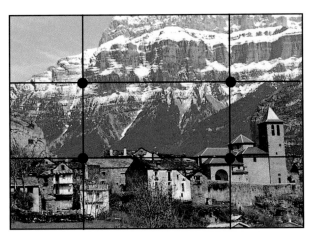
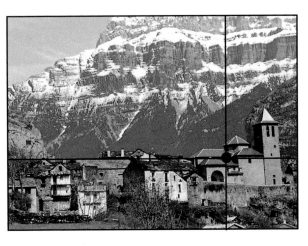

Fig. 96. To illustrate the Golden Section rule, if we divide the length of the picture (top left) into two parts, in a three-to-two ratio, we see that there is roughly the same ratio between the smaller part and the larger part as there is between the larger part and the total length of the picture. The same formula is applied to the width of the picture (top right). To locate the golden point precisely, we measure the paper both horizontally and vertically and then multiply each of these two measurements by 0.618. The resulting figures will tell us how far to measure in from the edges; the golden point will be located precisely where the new measurements meet.

Choosing a Landscape Theme

When he had just completed his training at the Royal Academy, the British painter J. M. W. Turner (1775–1851) had already achieved a level of expertise comparable to that of the great masters, demonstrating his precocious talent in his choice of themes, harmony of color, and skill at portraying atmosphere and perspective. Turner had the ability to draw and paint from memory, inventing shapes and colors and incorporating moving figures by working from simple sketches and quick studies drawn from nature (figs. 97, 98).

Looking for themes to paint, the famous American watercolorist John Singer Sargent (1856–1925) would organize excursions along the Thames, inviting several painters and friends to join him. The poet Edmund Gosse, among the participants, later described what Sargent did to choose his themes: "He would walk around outdoors with an enormous easel and would suddenly stand still wherever he found himself--behind a barn, behind a wall, in the middle of a field—his idea being to reproduce whatever he saw there." Though it's true that Sargent showed an indifference to theme by choosing subject matter almost arbitrarily, his motifs ranged over portraits, still lifes, landscapes, and seascapes (fig. 99), and he always spent a good deal of time contemplating his subject beforehand to analyze its formal, chromatic composition, seeing in his mind's eye how he would interpret it.

By studying the way master watercolorists worked, we can conclude that the choice of theme depends on three basic factors: knowing how to see, knowing how to compose what you see, and knowing how to interpret what you see.

This means looking at a landscape motif while reflecting on the best format for it, the best vantage point from which to paint it, and what its lighting and chromatic structure will be. It means analyzing composition, deciding what should be left out, what should be emphasized, which colors should be dominant, and which contrasts should be accentuated.

97

98

Fig. 97. A dramatic landscape by J. M. W. Turner, 1804.
Fig. 98. A misty canal scene by J. M. W. Turner, 1840.
Fig. 99. Bright sailboats by John Singer Sargent, 1908.

99

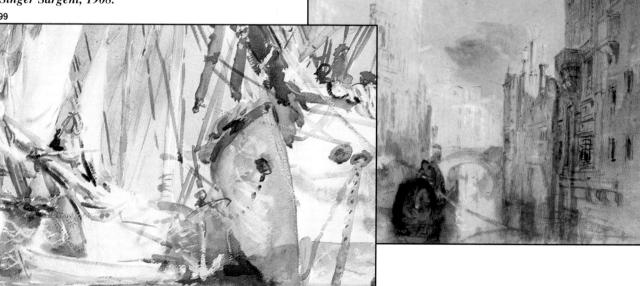

Selecting Objects for a Still Life

100

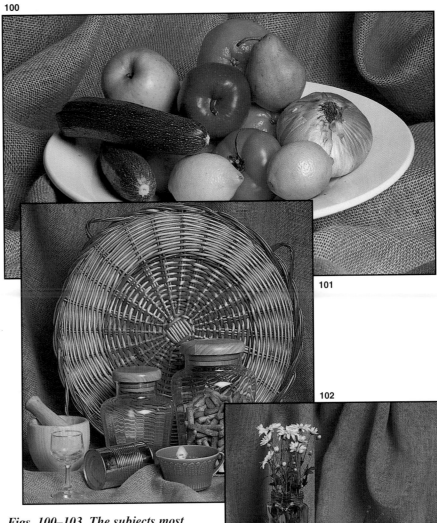

Up to now, I've focused on painting from nature and the many preparatory steps needed for painting landscapes in watercolor, from finding a theme to composing it and handling perspective.

In painting a still life, composition is paramount, and the choices for it fall entirely and exclusively on the artist. As a beginner, your first emphasis should be practicing composition by studying the exercises in arrangement described earlier (pages 34, 35). Begin by drawing very simple arrangements and making them increasingly complex, as long as you keep in mind the principle of "unity within diversity."

Just as you have endless options in combining and arranging objects for a still life, your decisions about color are also very broad. Even working only with the most ubiquitous subject matter, you always have at your disposal the chromatic possibilities offered by fruits and vegetables (fig. 100) and the wide range of greens in household plants; the colors of tablecloths, dishes, ceramic pieces, and other table accessories (fig. 101). The reasons for choosing flowers and plants (fig. 102), fruits and crockery (fig. 103) for a still life lie both in their varied shapes and colors and in the endless compositional possibilities that they present.

Choosing flowers and fruits is easy. Flowers from your garden, if you're lucky enough to have one, wildflowers gathered in the countryside, or a simple bouquet bought at the market all make excellent subject matter for practicing still life in watercolor. Traditionally, artists like to include ceramic, glass, metal, or porcelain objects, all of which offer varying shapes and textures that will enhance a painting.

101

102

Figs. 100–103. The subjects most often used in still lifes are fruits, vegetables, and flowers, and for good reason, given the great variety of colors, shapes, and endless compositional possibilities offered by them. Wicker, glass, metal, wood, and ceramic objects are also ubiquitous in still lifes because of their range of textures, shapes, and colors. As long as they are well composed, successful still lifes may display dozens of different objects or just a simple little pitcher and two pieces of fruit.

103

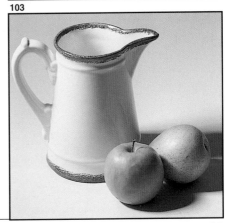

Basing Composition on Geometric Forms

Through the rule of the Golden Section, you've already learned to organize the space in your painting and to make the center of interest in your theme stand out. Now we'll be talking about choosing a geometric pattern to follow when blocking in the main elements of your drawing. But why should we base the composition of a work of art on a geometric form?

The German philosopher Gustav Fechner (1801–1887), who studied the relationship between the physical and psychic phenomena of shapes, found through statistical analyses that when choosing among various shapes (fig. 104), a great majority of people prefer geometric forms because of their simple and concrete configuration. The results of Fechner's research are confirmed by many works of fine painters (figs. 105, 106), who used the basic square, triangle, diamond, and circle to guide symmetrical compositions for their art.

In trying to account for this simple and concrete preference, one writer on the subject, C. R. Haas, theorizes: "The authentic power to bewitch held by certain shapes and groups of shapes is the consequence of the principle of hedonism, getting maximum satisfaction with minimum effort, or the principle of muscular, nervous, and mental economy."

104

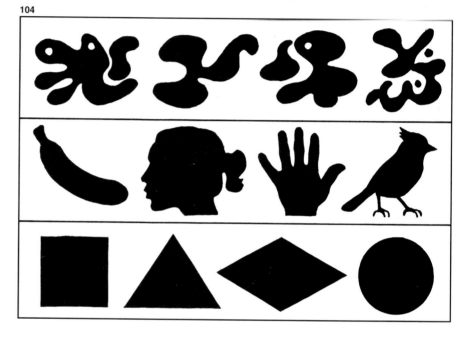

Fig. 104. Using these graphic silhouettes, philosopher Gustav Fechner showed that when asked to choose between abstract, natural, or geometric shapes, most people prefer the latter.

Figs. 105-110. The choice of a geometric configuration underlying a painting is integral to a successful composition, as illustrated by the fine paintings on these two pages.

105

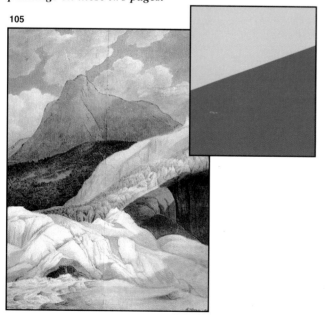

106

The use of geometric forms can be seen as early as the Renaissance, when there was a general reliance on triangular configurations. Baroque art brought a trend toward the use of diagonals, its most notable application seen in the work of Rembrandt. In addition to classic geometric forms used when blocking in a composition, other traditional choices are patterns akin to letter forms, such as a C, an L, and a Z. In the handsome paintings on this page (figs. 107, 108, 109, 110), some of these shapes are readily apparent. The examples shown demonstrate how the geometric base of a composition brings it unity and cohesion.

So when you're all set to start a painting and need to decide on its format and composition, before blocking in its main elements, try to find a design that conforms to a geometric shape. Consider choosing your vantage point for a landscape painting—where to position yourself in relation to your subject—so that the elements follow a certain geometric form. If you put this advice into practice, you'll be sure to turn out harmoniously composed, visually satisfying paintings.

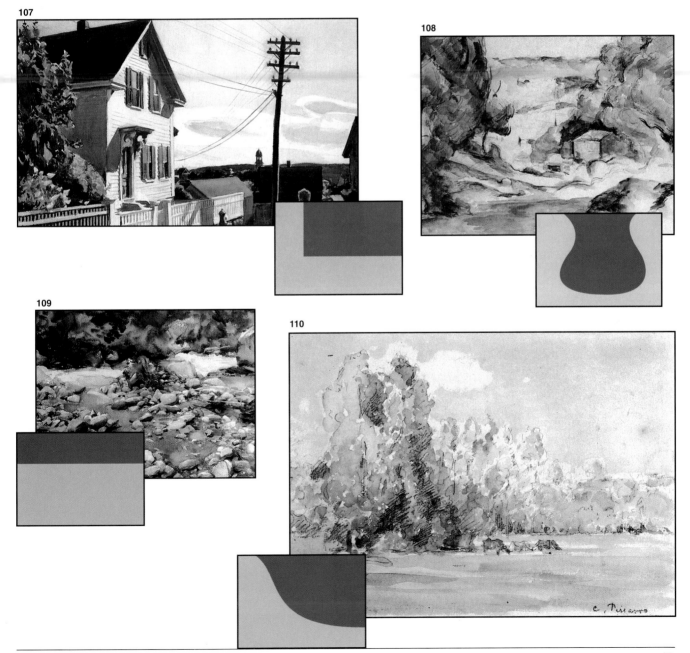

107

108

109

110

This wonderful portrayal of Somerset Place in Bath (fig. 111) by the contemporary English watercolorist John Piper affords us a perfect example of a work that holds the eye because of its magnificent technique, extraordinary tonal contrasts, and lively composition. What geometric forms would you say underlie this work?

Variety seen in the gorgeous watercolor still life (fig. 112) by Paul Cézanne (1839–1906) comes through his extraordinary contrasts in color and strong diagonal composition, transforming a simple bowl of fruit into a splendid work that catches and holds the viewer's eye.

Strong color contrast is also evident in a charming scene (fig. 113) by American Maurice Prendergast (1859–1924). On a trip to Venice, he painted many watercolors like the one shown, animated with large numbers of human figures. Can you identify the geometric basis of this composition?

In a lively watercolor landscape (fig. 114) by American John Marin (1870–1953), the use of strong texture, color and value contrasts, and imaginative composition add up to a superb example of variety within unity.

From all these fine examples, we can conclude that in composing a landscape or still life, three critical factors will create variety within unity: value contrast, color contrast, and texture.

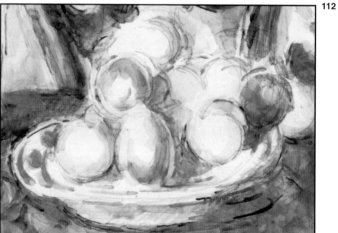

112

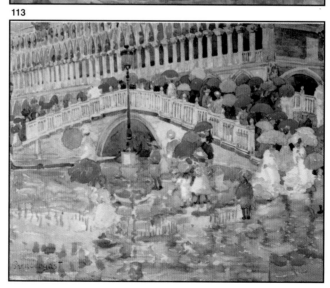

113

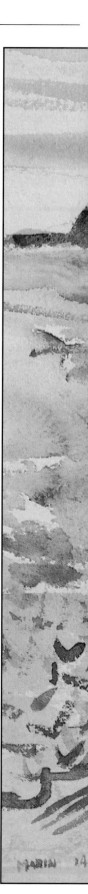

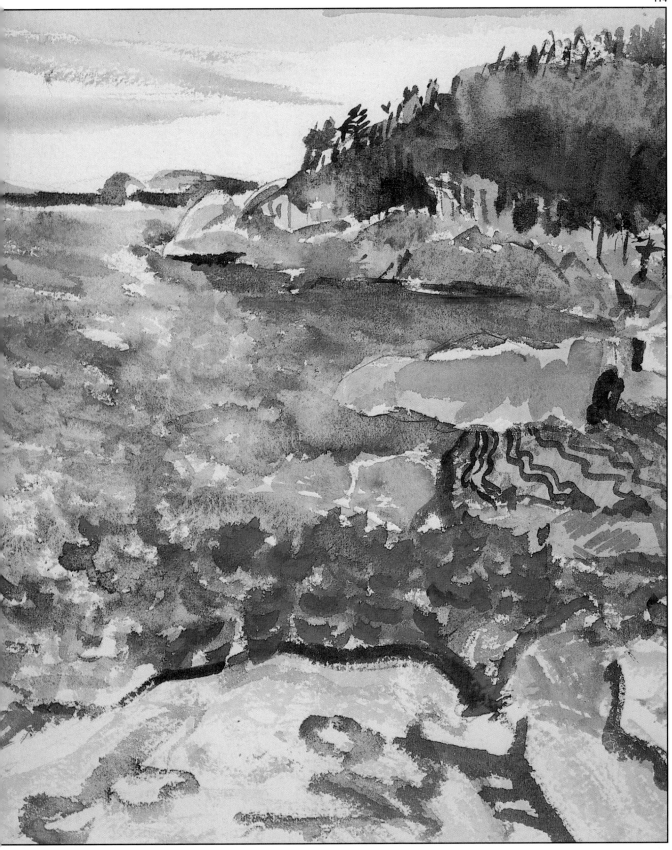

Capturing the Third Dimension in a Landscape

115

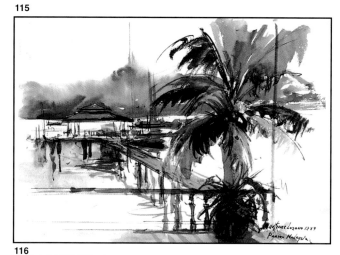

116

When we draw or paint, we work in two dimensions: height and width. The third dimension, depth, has to be simulated. Capturing the third dimension by representing distance between the foreground, middle ground, and background is another important factor in the art of composing a painting.

Thus, in addition to learning the techniques we've reviewed for simulating volume and atmosphere, to be a successful watercolorist when painting landscapes, you must be able to convey an impression of depth and distance in your picture. There are several ways to approach this challenge.

Emphasizing foreground: Working from a vantage point that situates a strong element at the front of the composition, such as a tree (fig. 115), fence, or any object of known size, enables the viewer to relate the scale of that object to remaining content in the middle distance and background.

The *coulisses* effect: French for "wings" of a stage, this effect occurs when elements arranged at the sides of a picture tend to direct the viewer's eye toward some central point, thereby suggesting depth through successive planes (fig. 116).

Geometric pattern: A common means of portraying the third dimension is by applying the principles of perspective as related to a predetermined geometric pattern (fig. 117).

Evoked contrasts: Painting contrasts that don't really exist in your subject (figs. 118, 119) is a way to emphasize contours, separate objects, and make shapes stand out. Leonardo da Vinci said, "The background surrounding a body should impart darkness to the lightest part and light to the shadowed part." This theory is also valid for portraying depth.

Color temperature: Warm colors (red, orange, yellow) seem to come forward in a painting, while cool colors (purple, blue, green) seem to recede, appearing farther away from the viewer. An experiment with bands

117

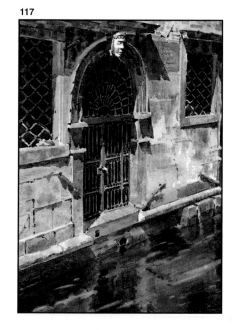

Fig. 115. In this watercolor painting, the height of the palm tree in the foreground, contrasted with much smaller objects in the background, serves to emphasize the scene's depth.
Fig. 116. Superimposing successive planes creates depth in this landscape.
Fig. 117. This is an excellent example of architectural detail painted in accordance with the rules of perspective.

of color (fig. 120) demonstrates this principle. Observe how the yellow/ orange seems closer, the blues farther away, and the greenish red in the middle distance. Applying this chromatic scheme can help suggest depth in a painting.

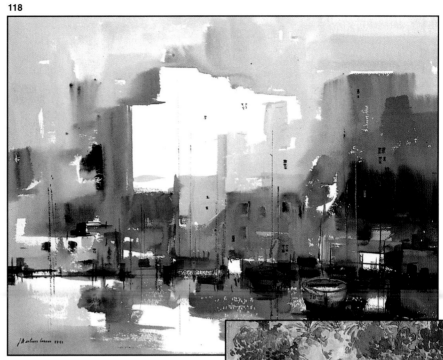

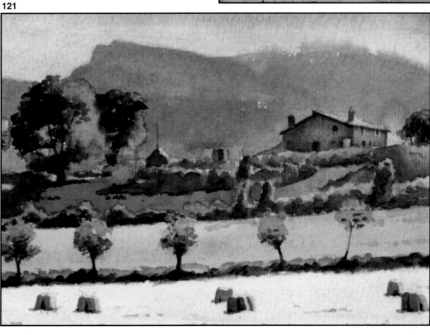

Figs. 118–119. Evoking a contrast in colors helps define and emphasize particular shapes in this freely interpreted harbor scene.

Fig. 120. Observe how blue, a cool color, seems farther away than yellow, a warm color. Thus, cooler colors generally belong in the background; hot colors in the foreground.
Fig. 121. In this painting, the artist concentrates warm colors in the foreground and middle ground, saving cool blues for the distant background.

Interpreting Landscape and Still Life

In broad terms, there are two ways to paint. The first is realistically, where we try to represent natural or man-made objects as they exist, coming as close to their shapes and colors as our talent and artistic skills allow. The second way to paint is by interpreting the model in a personal way. Impressionists, for example, minimize details, alter nature's colors, and distort shapes, but still paint a picture that contains easily recognizable objects. Other artists abstract their work even further, relying heavily on imagination and fantasy.

Of these painting styles, there's no doubt that the second option allows artists more creative freedom in conveying their own impressions and emotions when transforming a landscape or still life into a work or art.

In his diary, painter Eugène Delacroix (1798–1863) wrote, "You have to look inside yourself and not at your surroundings." Similarly, a century later Pablo Picasso declared, "The painter has to capture his internal impressions and visions in his painting."

In effect, as a watercolorist, you should approach painting with the desire to alter and interpret what you see in your own way. By combining the reality of your subject matter with your own preferences—modifying images and colors, changing, adding, and subtracting elements, you'll be putting your personal stamp on each of your works.

To elaborate on this idea, let me make a few suggestions as well as offer some concrete guidelines on artistic interpretation.

The first step, as always, is to study the theme for a good while to see whether there is any possibility of improving or modifying certain shapes. Naturally, in an imaginative analysis the artist considers whether it's a good idea to omit certain elements that may sully the picture, such as poles or electric wires, billboards, or other intrusive objects. Perhaps the

format—vertical, horizontal, or square—should be varied from the most obvious choice. Maybe contrasts in the foreground, the atmosphere of the middle distance and background, and the range of colors in general should be distinctly different from what you see before you.

Creativity depends on the ability to combine the subject's real image with imagined or remembered material. Exemplifying this approach is a hand-

122

some watercolor by Paul Gauguin (1843–1903) found in a travel notebook (fig. 122).

German artist August Macke (1887–1914) also painted while traveling. On an African trip he interpreted a village street (fig. 123) using strong geometric shapes.

John Constable (1776–1837) interpreted his own English landscape powerfully when he portrayed Stonehenge (fig. 124).

The magnificent sunflowers (fig. 125) on the facing page by the German painter Emil Nolde (1867-1956) bespeak a passion for his subject that is expressed through hot colors like these in much of his work.

123

Fig. 122. A Tahitian landscape by Paul Gauguin, 1891.
Fig. 123. A street scene by August Macke, 1914.
Fig. 124. Stonehenge by John Constable, 1836.
Fig. 125 (opposite). Sunflowers by Emil Nolde, 1937.

124

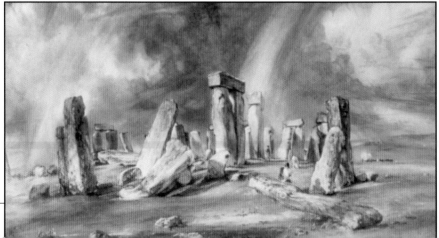

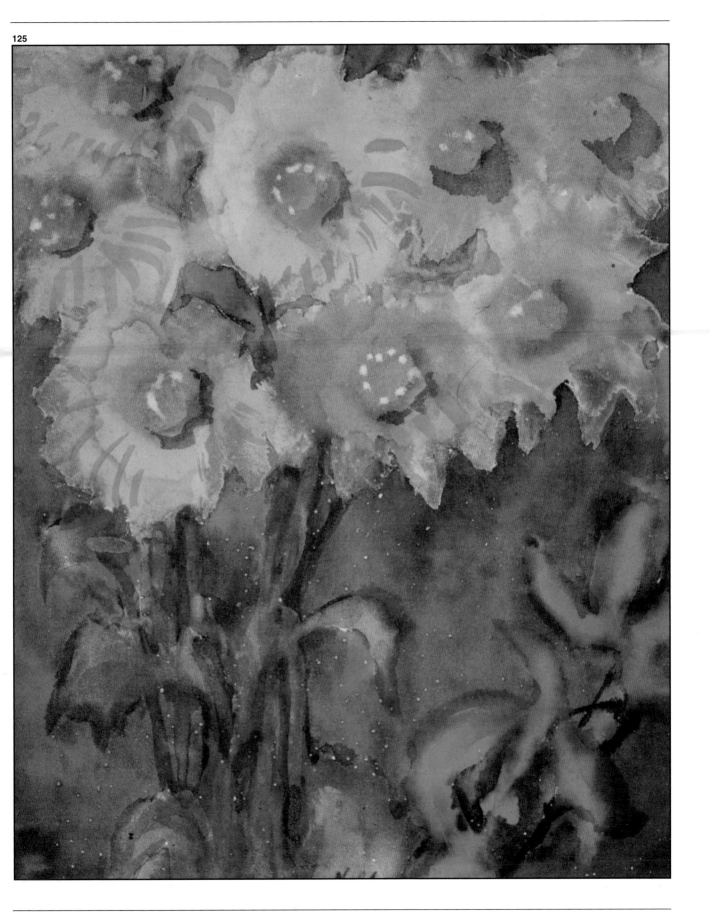

Having reflected on the originality that many artists bring to interpreting colors, let's look at the skill of exaggerating existing contrasts; that is, adjusting lights and darks so that they differ somewhat from the tonal values presented by reality.

A painting by contemporary Spanish painter Marià Fortuny (fig. 126) is characteristic of the exaggerated contrasts between light and shadowed areas that she often brings to her watercolors, as in this scene featuring brilliant light flooding one of the walls of a handsome Sevillian courtyard.

Merche Gaspar, whose work appears often in this book, uses purposeful exaggeration in portraying a group of casually arranged objects (fig. 127). By intensifying both light and dark areas, she causes objects to stand out through the technique of simultaneous contrast.

To sum up the major points made in our discussion of interpreting subject matter for landscapes and still lifes, I would say that three verbs tell the story: enlarge, diminish, omit.

Enlarge: Exaggerate contrasts and the luminosity and intensity of colors or enlarge the size of various elements in a composition.

Diminish: Fade, soften, or reduce the size of trees or the width of a road, the color of fields and mountains, or the volume of clouds.

Omit: Cover or cancel out elements in the foreground that strike a discordant note, such as an asphalt road crossing a field, a tractor, a truck, or an intrusive farm structure.

Putting these three factors to work for you is not exactly a magic formula, but it's the only one I know for learning to interpret subject matter according to one's own vision.

126

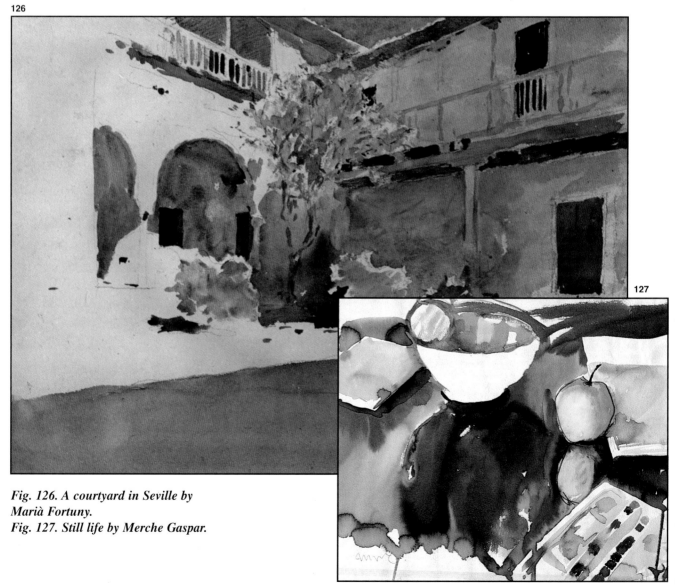

127

Fig. 126. A courtyard in Seville by Marià Fortuny.
Fig. 127. Still life by Merche Gaspar.

Tonal Values Versus Flat Color

128

In a treatise on painting, French teacher/artist André Lhote classifies "two large families of painters" as the "colorists" (fig. 128) and the "tonalists" (fig. 129).

"Colorists" portray shapes using flat colors, omitting or minimizing shadows, relying on color itself to separate objects and express their shapes. The work of Henri Matisse (1869–1954) famously uses large areas of flat color to express volume. Pierre Bonnard (1867–1947), another great proponent of the style said, "On its own, color is capable of representing mass and volume." In landscape painting, flat color application has a distinctly contemporary look.

"Tonalists," associated with a more traditional painting style, are painters who strive to portray variations in the play of light and shadow on objects (fig. 130).

Fig. 128. The apple to the left is painted in a style I refer to as "colorist," using a somewhat flatter application of color than the apple shown below.

129

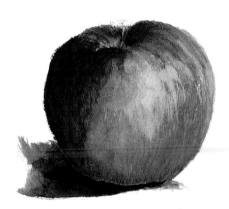

Fig. 129. This apple is painted in the style I call "tonalist," whereby volume is created by shadows on the apple itself and shadows cast on the surface beneath the apple.

Fig. 130. There are two ways of executing a watercolor painting: depicting reality by imitating nature and reproducing shapes and values seen in the subject, or, as exemplified by this Gaspar Romero painting, interpreting objects in your own way, altering reality by taking liberties with colors, shapes, and textures. Adding, subtracting, and inventing elements in a painting are all part of the creative process.

130

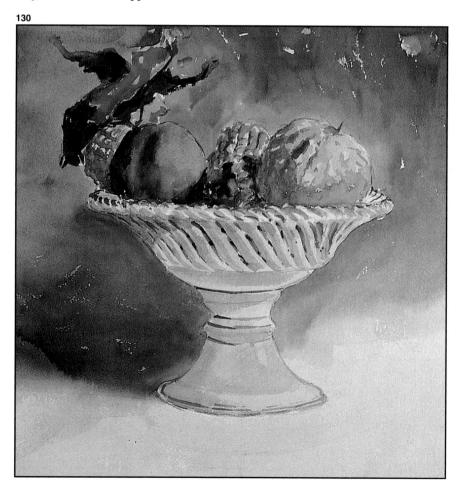

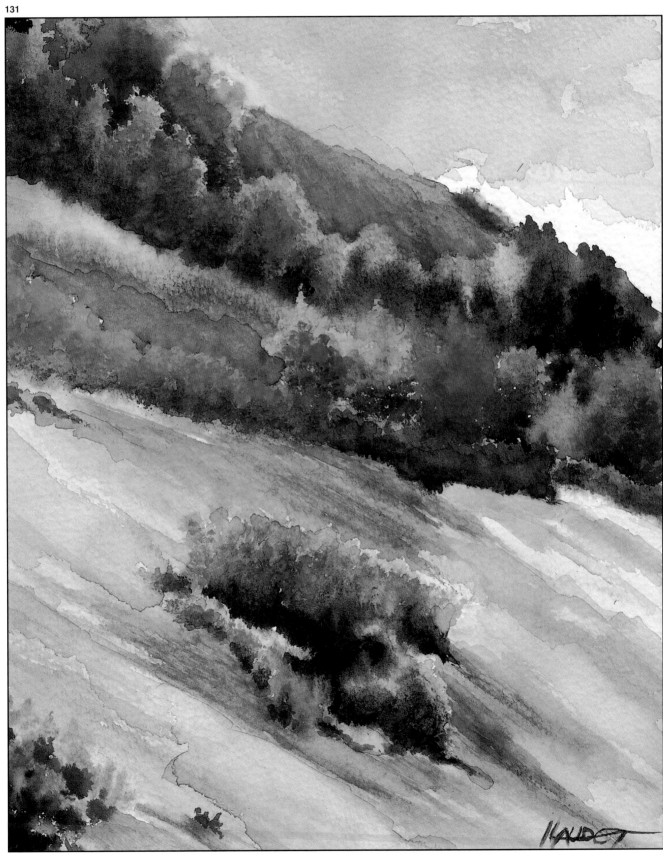

"Tonalists" describe shapes through tonal values, molding objects with gradations of color, using a wide range of light tones and dark shades both on objects themselves and in the shadows they cast. Camille Corot (1796–1875) is a notable master of this classic technique, and many contemporary painters also build their work around strong tonal values (figs. 131, 132).

When evaluating painting styles and experimenting with them, always keep in mind that there are neither good nor bad styles, but only good and bad ways of executing them. Nor should it be a question of favoring one method to the exclusion of the other. Fine artists who preferred painting with flat colors have included geniuses such as Picasso, while other great masters have empha-

sized volume and modeling above all in their work.

132

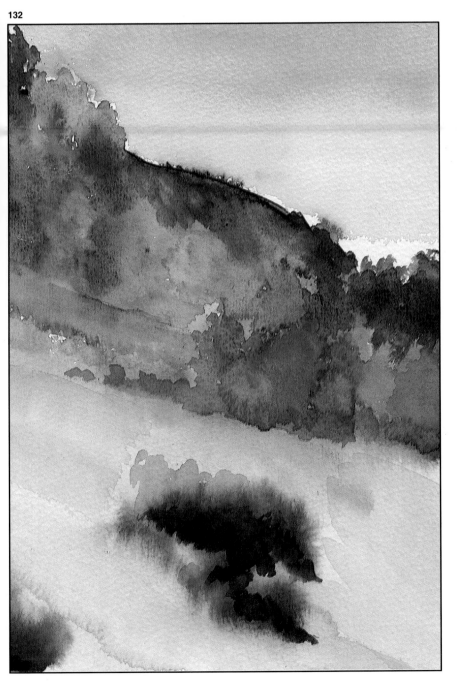

Figs. 131–132. The same landscape painted in two different ways by the watercolorist Ester Llaudet shows flatter application of color in the rendition on this page, where the shapes of vegetation are expressed not through chiaroscuro, which would employ gradations of light and shadow, but through separate areas of flat color that abut one another.

By comparison, the painting on the previous page expresses the shapes and volume of foliage through tonal values and the lively play of light and shadow, a technique that is closer to traditional watercolor paintings of the past century.

STEP-BY-STEP
EXERCISES

This chapter features a series of practical exercises based on themes painted by professionals who have broad watercolor expertise. You can easily follow these step-by-step exercises without a teacher. Many of the projects are accompanied by watercolor sheets that have printed patterns designed to help you carry out the lessons and put into practice various principles and techniques discussed earlier in this book.

Stretching Watercolor Paper

If you're getting ready to paint with watercolors on a piece of paper that is lighter in weight than 300-lb. and larger than 20 x 24" (51 x 61 cm), stretching the paper is absolutely necessary. This means soaking the paper and then taping or stapling it to a rigid board and letting it dry thoroughly, which will tighten and shrink it somewhat. The paper will then be able to absorb moisture from the washes you apply, without warping or puckering.

For this process, work on a sturdy board: 3/4" (2 cm) plywood is a good choice. It should be larger than the paper to be affixed to it. Heavier papers (90-lb. to 300-lb.) should be soaked on one side under the tap for about two minutes (fig. 133). Place the wet paper on your board and immediately tape it down, using brown, gummed tape (fig. 134).

Continue taping until the whole sheet is securely affixed to the board (fig. 135). Then let the paper dry for four or five hours, making sure the board lies flat. I don't recommend shortcuts for drying paper; that is, don't use heaters, hair dryers, ovens, or even intense direct sunlight. If you dry the paper correctly, the surface will be smooth, tight, and wrinkle-free, no matter how much water you put on it as you paint.

133

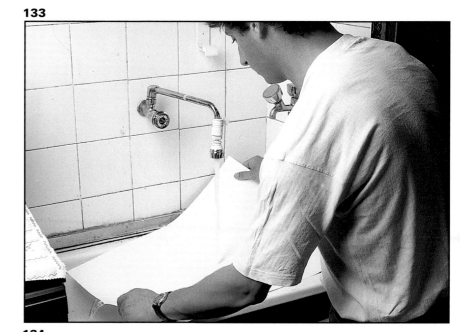

134

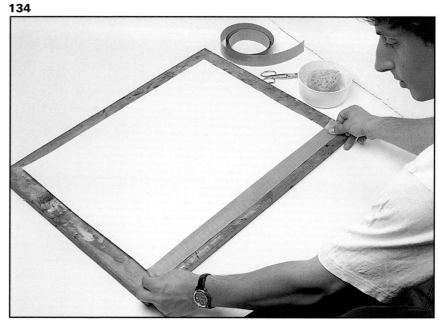

135

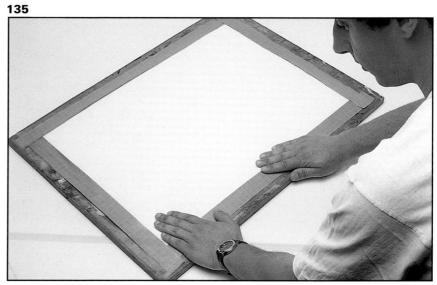

Fig. 133. The first step in stretching a large sheet of paper is to wet it under running water for about two minutes.
Fig. 134. Once the paper is soaked, one of its edges is immediately affixed to a support board with gummed, brown paper tape.
Fig. 135. The remaining edges are quickly taped in place.

Lighter-weight papers (25-lb. to 80-lb.), especially for smaller paintings such as a 9 x 12" (23 x 33 cm) watercolor, can be wet with a sponge, then attached to the board, using a staple gun (fig. 136). Another method is pulling the paper over the edge of a wooden frame like those used for oil paintings (fig. 137). Or, use thumb-tacks or clips (fig. 138) to hold the paper in place.

137

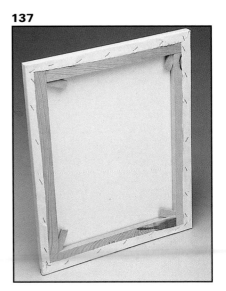

136

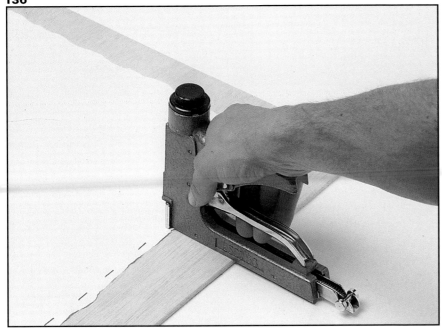

138

Fig. 136. Heavy, medium-size paper can be moistened with a wet sponge then stretched and affixed to a board using a staple gun.
Fig. 137. Another method of stretching paper is to staple it to a wooden frame.

Fig. 138. Heavy papers can also be mounted wet on the board and held in place with thumbtacks or clips.

Painting Basic Geometric Forms

In this exercise, watercolorist Merche Gaspar shows how to paint a simple still life of three basic geometric forms: a cube, a rectangular block, and a cylinder, lit with a low light coming in from the left side (fig. 139).

Instructions for building these three forms (fig. 141 and 142) are included below, or instead, perhaps you'll find these basic shapes in something such as ready-made boxes and a cylindrical vase.

Once your still life is set up, the first step in painting it is to mount your paper on a rigid support. Then, using a #2 pencil to make a line drawing (fig. 140) with no shading, place the cube at the center of the composition. Continue drawing by adding the other two shapes flanking the cube. Make sure the cylinder and rectangular block are about twice the height of the cube, and that one edge of the cube is right in the center of the rectangle's front face.

139

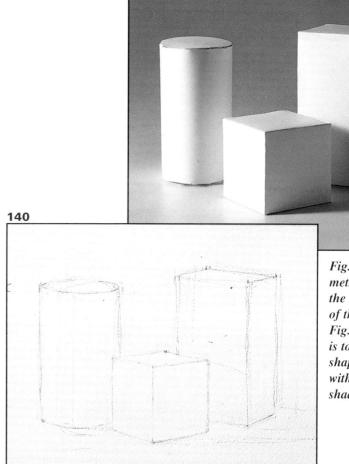

140

Fig. 139. Three geometric forms, lit from the side, are the basis of this exercise.
Fig. 140. The first step is to draw the three shapes in outline only, without including any shadows.

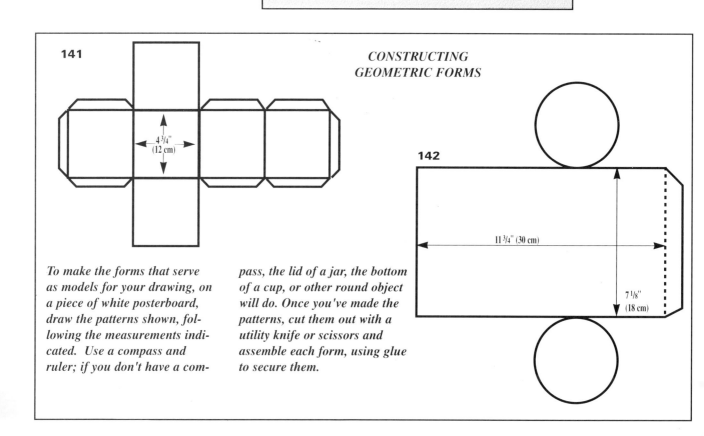

141

4 3/4"
(12 cm)

CONSTRUCTING GEOMETRIC FORMS

142

11 3/4" (30 cm)

7 1/8"
(18 cm)

To make the forms that serve as models for your drawing, on a piece of white posterboard, draw the patterns shown, following the measurements indicated. Use a compass and ruler; if you don't have a compass, the lid of a jar, the bottom of a cup, or other round object will do. Once you've made the patterns, cut them out with a utility knife or scissors and assemble each form, using glue to secure them.

Merche chose a round #10 sable brush for this exercise. She mixed ultramarine blue and sienna to make gray, but I suggest you use a single color, Payne's gray, to make things easier for you. Spread a uniform wash on the tops and darker sides of the forms in your drawing, leaving the most brightly lit sides unpainted for the time being (fig. 143).

When your first wash has dried, deepen those shadows, varying tones as shown (fig. 144). Apply a darker coat of the same grayish color to the sides that are in a darker shadow, but don't paint the cast shadows yet.

To portray the cylinder's tonal gradation, begin by painting a dark gray vertical stripe on it (fig. 145). After cleaning your brush with water and squeezing it out a bit, dilute the stripe of color, creating a gradation toward the illuminated side. Load your brush with paint again, then work on the dark part of the cylinder, tipping your board about 90 degrees and painting with horizontal strokes from top to bottom until you reach the base of the cylinder.

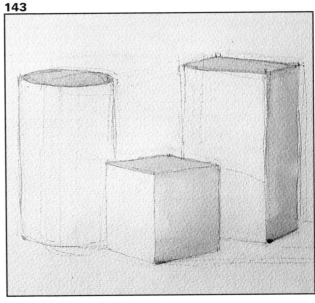

143

Fig. 143. On your line drawing of the three forms, first paint the tops and shadowed sides with a very diluted wash of Payne's gray.

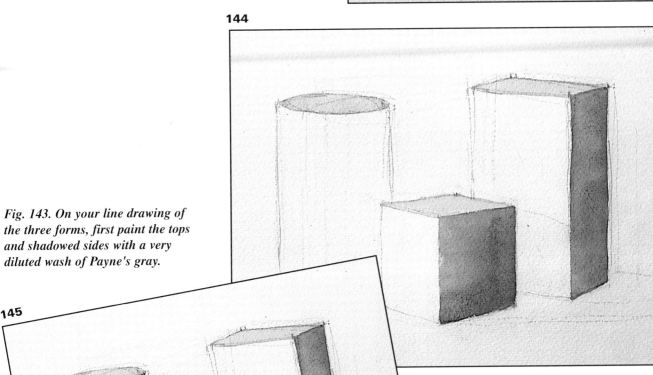

144

145

Fig. 144. Go over the sides of the cube and the rectangular form with successive washes to define the effects of light, shadow, and half light.
Fig. 145. Begin shading the cylinder by painting in a vertical stripe, then add gradations of tone as illustrated.

Wait for the paint to dry, then with a wide brush, apply a dark coat of sienna to the background, accentuating the white, lit-up edges of the geometric forms (fig. 146). Once the right amount of color has been spread on the upper background area, clean your brush and load it with a generous amount of water. As you brush water in a downward direction over the sienna to dilute it, a light gradation of color will emerge on the lower background.

After the background has dried, paint in all the cast shadows (fig. 147). Note that the shadow projected on the rectangular block from the cube is painted in a value of gray that is lighter than the sides of the rectangle and cube. The cast shadows falling on the table surface from the forms are painted in a mid-value sienna.

Fig. 146. The artist applies a dark layer of sienna to the upper part of the background as a first step in painting a value scale that will lighten as it reaches the foreground.

Fig. 147. After painting shadows on the objects themselves, apply cast shadows by putting a glaze, or another wash, on top of the background tones.

146

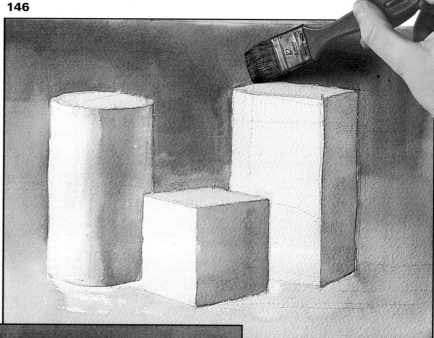

147

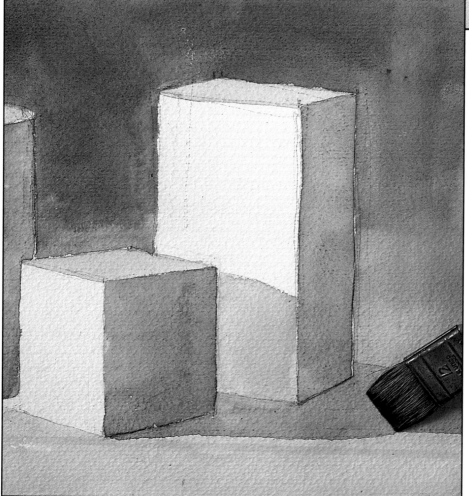

TIPS

Before painting, wet your paper with a wide brush or clean sponge to remove any traces of oil that your fingers might have left on the paper surface as you handled it when drawing.

Whenever you're trying to show tonal gradations, work on wet paper.

Remember that you can always retouch small imperfections by opening up white spaces with a utility knife, as described earlier (page 21).

148

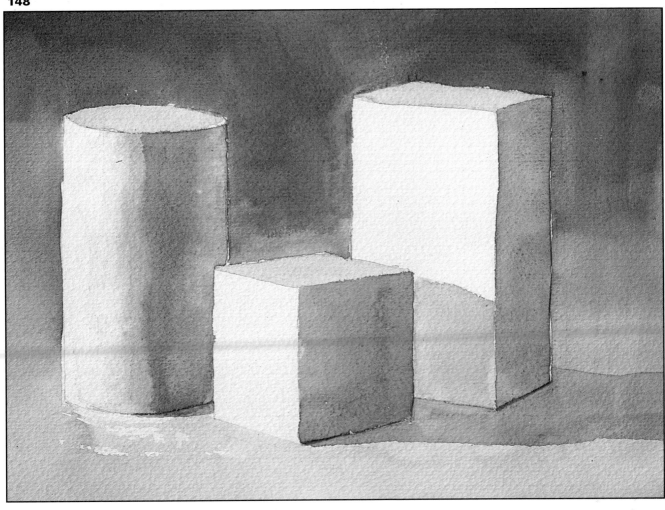

As always, in the last step (fig. 148) finishing touches are added, such as accenting the base lines of the three forms and other subtle details.

It's been said many times that we learn by doing. The only way to develop as a painter is by painting, and the exercise we've just completed is an excellent way to practice using washes. In fact, all the skills needed to carry out the many exercises that follow can only be gained through continual practice.

If you had problems reproducing the tonal values shown in this exercise, I suggest that you try again, keeping another piece of paper on hand so that you can experiment with gray tones before applying them to your final painting.

In fact, it's a good idea to repeat all exercises many times. Doing so will help you to acquire the skills and confidence needed to be a good watercolorist.

Fig. 148. The completed exercise is interesting from a technical point of view in that it shows how just a single color for the objects and a second color for the background can produce a painting full of tonal values in some areas while having smooth, uniform washes in others.

Drybrush Still Life

This exercise is based on an eye-catching still life with an asymmetrical arrangement (fig. 149). The technique we'll use is just as suited to landscape, seascape (fig. 150), and other subject matter as it is to still life.

The technique is known as drybrush, whereby watercolor pigment is used scantily and applied undiluted on rough-textured paper, so that the paint clings only to the raised parts of the surface, leaving the valleys of the fiber weave blank (figs. 151, 152).

For this exercise, you should use pattern number 1 from the back of this book.

149

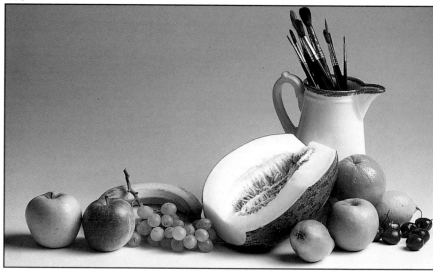

Fig. 149. The set-up for this colorful still life surrounds a pitcher holding paintbrushes with several varieties of fruit.

Fig. 150. The drybrush technique used in this magnificent watercolor painting by Edward Seago is the method featured in the exercise on the next pages. Its special quality lies in its spontaneity, in that shapes and colors are resolved alla prima, meaning "at first," without underpainting or retouching.

Figs. 151–152. The drybrush technique consists of painting with undiluted color on the surface of rough-textured paper without getting pigment in the paper's hollows. Referring to the examples below, at left, we see brushstrokes made by using a normal amount of transparent wash; at right, we see color patches made by the drybrush technique, using undiluted paint applied sparingly but thickly with a brush that is dry or almost moisture-free.

150

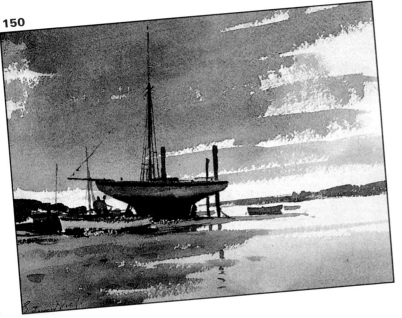

151 **152**

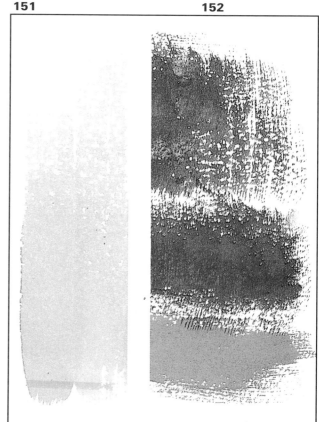

153

I begin by making a line drawing with a 2B pencil on paper divided into four equal sections to guide placing objects in proper scale (fig. 153).

To start painting, first comes the background, for which I use a mixture of Payne's gray and cadmium red (fig. 154). Although drybrush usually means using minimal water, for this background, I begin with a generous amount. Using my #12 sable brush, I paint nearest the bottom of the paper (working with the board turned upside-down), outlining the shapes of the fruit and other items. As I move into the lighter area of background, I dry my brush and then rub and tone the color. When it's dry, I repeat the procedure, using a darker tone as I get closer to the fruit.

Fig. 153. My first step, a line drawing, is made on a sheet of paper that's been divided into equal quadrants, aided by vertical and horizontal guidelines. Then the outlines of all the objects in my still life are penciled in lightly.
Fig. 154. I start shading in the background with a mixture of Payne's gray and a little alizarin crimson, using the drybrush technique.
Fig. 155. Applying my first fruit colors, to ensure that all the fruit have bright highlights, I let spots of paper white show through on each piece.
Fig. 156. After painting shadows on the inside of the pitcher's mouth and on its handle, I use the same mixture on the melon rind.

154

155

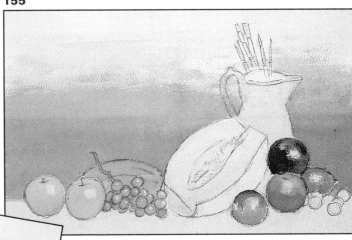

156

Painting the fruits in their appropriate colors (fig. 155), I work from light to darker values, modeling each form by portraying the effects of light and shadow on them. My palest wash is saved for the melon pulp and the pitcher.

Cast shadows from the melon create deeper values on one side of the pitcher; my darkest color mix is used on the melon rind (fig. 156).

By wiping my brush frequently until there is almost no moisture in it (fig. 157), the drybrush technique continues to play on the unevenness of the paper grain so its rough texture stands out. To make sure your brush is doing its job, check it on a separate piece of paper of the same quality as the one you're painting on, to remove any excess liquid. This test works best if you flatten the bristles on the brush from time to time, forming what looks like a little comb. This will make drybrush painting easier because your brush will move across the paper touching only the peaks and not the valleys of the paper fiber.

This step of the exercise is where the objects are all more clearly defined (fig. 158). I paint cast shadows under the fruit and mold each piece, using curved brushstrokes to express their volume. Once you're up to this point, it's time to step back and carefully examine the whole painting to see where final touches are needed.

157

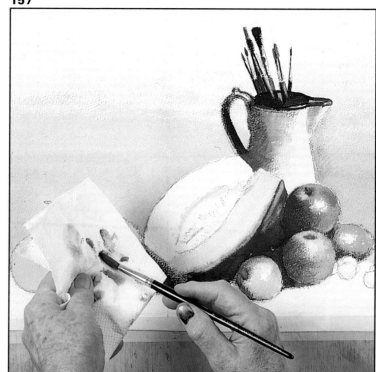

158

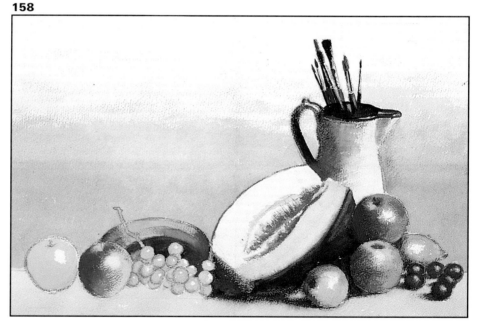

Fig. 157. The drybrush technique entails removing water from the brush by blotting it on a paper towel until it's almost completely dry.

Fig. 158. I intensify the color of the fruit, paint the cast shadows, and start adding details using a smaller brush.

159

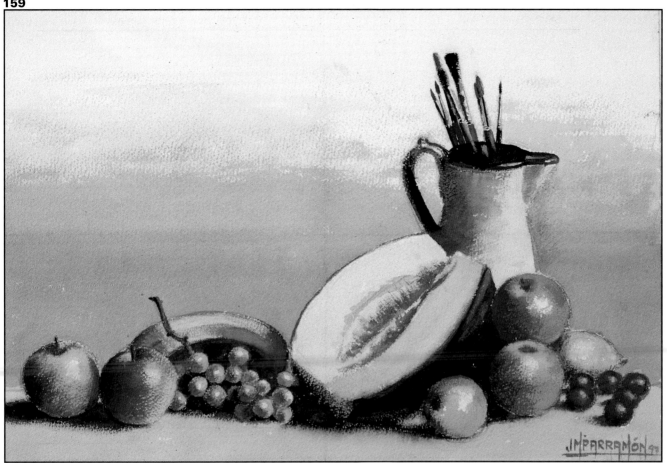

My last detail work is concentrated on the grapes and apples on the left (fig. 159), and you can readily see how improved they are with more shading and cast shadows added.

Studying the finished painting, if you look at the background and the melon pulp, you'll see that the paint applied in those areas isn't as thick as on the fruit or on the paintbrushes in the pitcher.

This tells us that the drybrush technique is at times not as dry as its name implies. So my picture really combines two techniques: First, I paint a tonal gradation using a brush loaded with paint and water; then I remove moisture from the brush and let the drybrush technique take over by rubbing the brush against the grain of the paper to make its texture stand out.

Fig. 159. In my completed still life, the drybrush technique is evident in the lively textural effects it has produced.

Scraping Enhances a Woodland Scene

A common characteristic of fine watercolorists is their respect for the white of the paper, allowing that lightest of all values to come through by leaving areas of paper untouched by paint. Nevertheless, sometimes underpainting and other techniques won't allow reserving white space, and in those cases, even the best professional painter will have to find another way to bring white into the picture. This exercise shows one good way to do it.

Working on a dry watercolor painting, we're going to open up white spaces with a utility knife. The X-Acto knife, with a pointed blade, is a brand favored by many artists. Use pattern number 2.

With a photograph (fig. 160) for reference, artist Jordi Segú focuses his painting demonstration on a section of a stream running through leafy dark woods, to which he'll add a white cobweb for contrast.

He begins by drawing a group of small, rounded shapes to represent stones in the stream (fig. 161), then with quick linework adds branches and two diagonal lines that will become the trunk of the tree in the center of the composition.

Next, he starts covering the white background with an olive-green wash, a bluish wash for the dark underbrush, and a pinkish wash for the stones (fig. 162). His interpretation is entirely free but establishes the general shapes and their placement, which will remain intact through to the final step.

The artist then lets the wash dry slightly and paints on top of it (fig. 163), using Payne's gray, then defines foliage shapes in the upper part of the composition. Moving to the lower section, through simultaneous contrast, he darkens the stream water while lightening the stones. He paints the main tree trunk and, with a finer brush, details the play of shadows among the rocks of the stream (fig. 164).

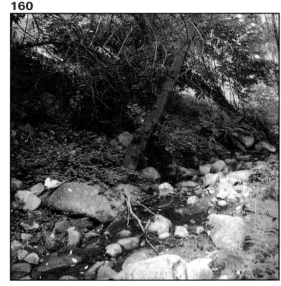

160

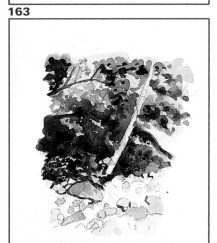

161

162

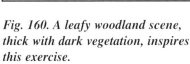

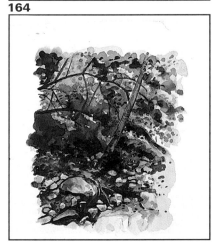

163

164

Fig. 160. A leafy woodland scene, thick with dark vegetation, inspires this exercise.
Fig. 161. All landscape paintings start with a sketch in which the outlines of major elements are blocked in lightly with pencil.
Fig. 162. A first pale wash is brushed on to break up the whiteness of the paper.

Figs. 163–164. Once the previous coat has dried, the paintbrush is loaded with a darker wash that is used to define the shapes of foliage, underbrush shadows, and dark water around stones in the stream.

165

166

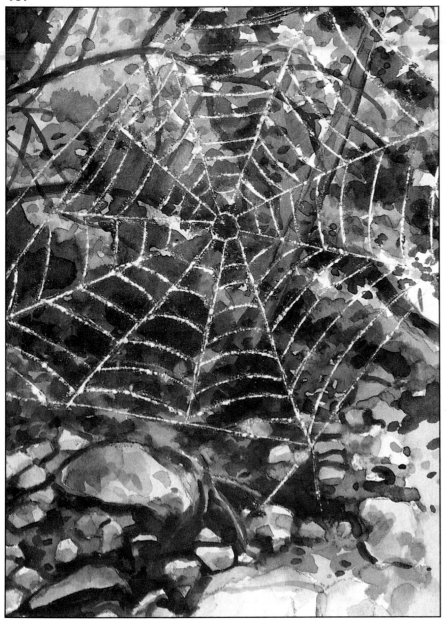

After adding more details in both the background and foreground, Jordi lets the painting dry for a few moments. Meanwhile, on another piece of paper, he makes a pencil drawing of the spiderweb (fig. 165) that he's going to superimpose on his painting.

With his sketch as reference, he uses a utility knife to draw the spiderweb on the background of the now-dry watercolor by scraping the surface of the paper with the point of the blade (fig. 166), making sure that it doesn't go too deep and cause holes in the paper.

In the finished work (fig. 167) you can see how effective the knife technique is in lifting off color.

167

Fig. 165. This drawing of a spiderweb is going to be superimposed on the woodland scene.
Fig. 166. White lines are opened up by scraping the dry painting with the point of a utility knife.
Fig. 167. On the completed painting, the white spiderweb adds both a wonderful contrast to a dark palette and an amusing, eye-catching focal point.

TIPS

If you don't have a utility knife, use any object with a needlelike point.

Be sure not to press the blade or other point down too hard on your paper, and don't go over the same area more than once or you might damage the paper surface and ruin your painting.

Using Salt to Texture Rustic Buildings

This exercise is based on the lively textural effects that result when ordinary table salt is sprinkled on a watercolor wash. The technique lends itself particularly well to the subject matter I've chosen: a group of rustic buildings that I came upon in a village.

As always, I start by sketching my subject in lightly with pencil (fig. 176), making an outline drawing only. If I were to draw in shadows, later, the watercolors would mix with those marks and the picture would be ruined.

My second step is optional: cutting out a piece of posterboard and placing it around the areas that will show the textural effects of the salt (fig. 177). If you work carefully with the salt, masking off other areas isn't essential.

In this case I've decided to use the salt on most of the stone walls. I start by applying some uniform washes of earth colors and cadmium red until the group of houses is completely covered (fig. 178).

While the painted area is still wet, I sprinkle a little salt on it (fig. 179). As the wash dries, each of the grains of salt will absorb the pigment and produce a halo of lighter color that will contrast with the background of the original wash.

To explain the chemical process, when submerged in the watercolor wash, as a grain of salt starts to dissolve, it absorbs the water from its surroundings, becomes more concentrated, and the sodium chloride discolors the area around it. The remaining crystals need to be removed, so after a few minutes, when the watercolor is completely dry, I brush off loose grains of salt. These remaining crystals are the ones that didn't have a chance to dissolve because the watercolor wash had already dried through evaporation.

Figs. 176–179. Putting the textural effects of salt to work in a small sketch of a village, I start by making a line drawing of the theme. By cutting a piece of posterboard and placing it on my drawing, I define the area on which I've decided to use these textural effects. I give the cluster of buildings a first coat and while it's still wet, sprinkle grains of salt over it.

176

177

178

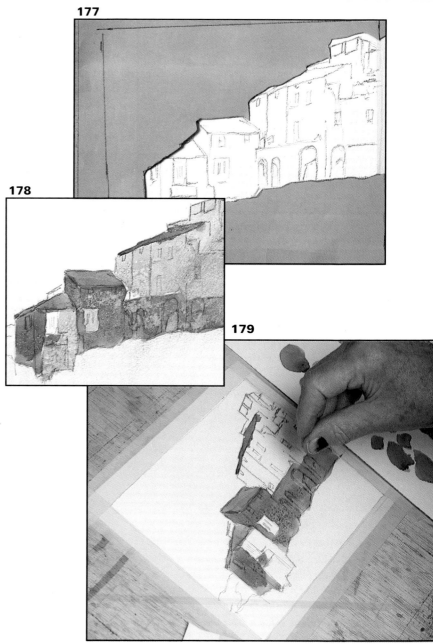

179

180

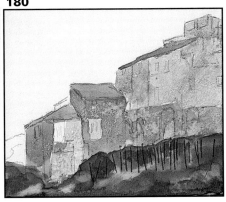

181

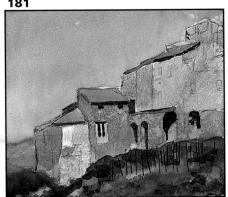

182

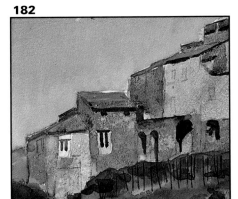

With the painting now developed further (fig. 180), you can see where small crystalline clearings have formed, looking something like snowflakes, but in the context of these buildings, the blotches begin to suggest the texture of stone walls. Using a wet watercolor technique, I continue to develop the foreground vegetation in deep ochres, browns, and greens. When the paint is dry, I choose dark brown to define the fence posts at lower right.

A uniform wash of ultramarine blue is just right for the sky (fig. 181). For the patch of low mountains at lower left, I mix ultramarine blue with a little carmine. Finally, dipping my brush in burnt umber, I start giving shape to deep shadows in the arches and other openings of the buildings (fig. 181).

Applying a second wash, I adjust the color of the walls and darken some of their shadowed planes to define the effects of light and shadow on them (fig. 182). I differentiate those houses with exposed stone from those covered by a coat of plaster. While this second wash is still wet, I repeat the earlier procedure of sprinkling salt to produce a texture.

My final steps include defining the windows, balconies, and doors with dark brown; darkening the blue of the sky; and accenting the fence posts by opening up white highlights on them.

Figs. 180–182. The salt absorbs the color and creates a fascinating texture on the walls of the houses. I continue to apply color, then paint the sky and mountains with uniform washes. Using some darker washes, I continue to retouch and contrast the cluster of buildings, repeating the salt technique for the second time. Fig. 183. The textural effects of salt enliven this village scene by imparting an extra measure of realism to the old stone buildings.

183

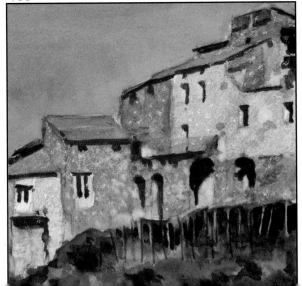

TIPS

When drying areas of a painting that have been treated with salt, keep your paper flat and on a rigid surface so that it won't curve or buckle.

If you wish to accentuate the textural effects created with salt, scrape some of the small white spots with a utility knife or other sharp point to highlight them further.

Painting Deep Distance in a Landscape

Ester Llaudet has chosen an expanse of serene Irish landscape (fig. 184) as her subject in demonstrating how to portray great depth in a watercolor painting.

Preparing to paint a selected landscape, the artist is always confronted with two basic decisions: which part of the scene to paint and how to interpret it. In this case, the artist decided to accentuate the landscape's depth by portraying a clearer and more contrasted foreground and fading out colors in the more distant parts of the scene, exaggerating the second aspect in particular.

With a sheet of blank paper before her, rather than beginning with a pencil sketch, Ester starts by wetting her paper thoroughly with a wide brush. She waits until it dries a little and then, using a #10 brush, tints the surface with a very diluted wash of lemon yellow, permanent green, and dark vermilion green (fig. 185).

Working quickly while the paper is still moist, she continues to establish the depth of the scene, using successive washes to indicate how elements will be placed in the final composition. She suggests the shoreline on the left, reserves white space for the sea, and puts in a faint strip of earth on the distant horizon in ultramarine blue (fig. 186). Notice how painting on wet paper makes the blue line of the distant coast spread out at some point and soften. It's also interesting that the artist has decided to leave the sky the white of the paper.

184

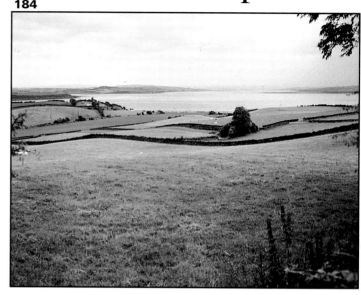

185

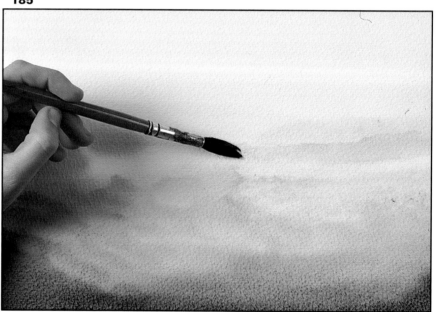

186

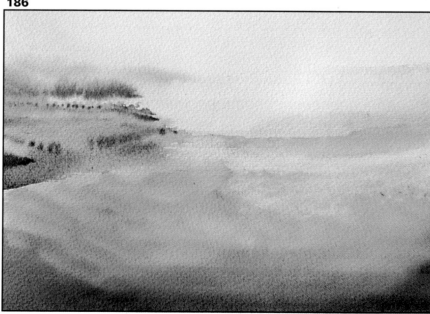

Fig. 184. The subject matter selected by Ester Llaudet is a typical Irish landscape with green fields close to the shoreline.
Fig. 185. The first step entails painting a series of transparent washes on wet paper, allowing the paper texture to breathe through the paint.
Fig. 186. Notice the effect obtained by painting the vegetation on a wet surface; at some point the streaks spread out, producing a vaporous aura.

187

188

189

190

Now, using darker colors, Ester starts to describe the lines of vegetation that separate the fields, some bushes in the foreground, and groups of trees fading into the distance (fig. 187).

Using a #3 brush, she continues to work on the vegetation, whose undulating forms express the contours of the land (fig. 188). As she places different colors on their appropriate planes, they spread out and become one with the moisture still present from the first coat.

Continuing to work on wet paper, after giving more body to the far shore and using darker values on the vegetation in the foreground, Ester ends up with more diffuse and blended colors (fig. 189). Also notice how shapes merge as they move to deep background. It becomes increasingly evident that as the planes go farther away from the viewer, the most distant shapes become bluish gray and look vaporous and indefinite.

In her final step, the artist accentuates depth further by adding clearly defined foreground vegetation whose shapes and color markedly contrast with the more distant, somewhat confused planes (fig. 190). This contrast strengthens and completes the landscape painting.

Fig. 187. The lines of vegetation, which suggest the contours of the land itself, are painted next.
Figs. 188–189. Ester continues to paint the vegetation on wet paper with a fine brush. She interprets the contours of a row of distant trees in her own way, masterfully achieving a sense of depth.
Fig. 190. This completed painting exemplifies the art of interpreting contrast and atmosphere freely in a watercolor landscape painting.

An Interior in One-Point Perspective

This exercise puts into practice principles covered earlier dealing with parallel, or one-point, perspective. Use pattern number 4. Once you've followed, absorbed, and replicated this exercise, try a watercolor painting depicting a room in your house or other interior setting that appeals to you.

In this case, the room is a kitchen. The first step, establishing the far wall, two side walls, floor, and ceiling (fig. 191), was done with the aid of drafting tools—a ruler, T-square, and angle. The red horizon line (HL), located at eye level, shows a single vanishing point (VP). From this point a series of lines will project in all directions. These lines will form the structure of the interior space, as if the room were a box containing all the basic structural elements.

Referring to the facing page (fig. 192), observe that the diagonal lines A, B, C, and D are the axes that define the limits of the overall rectangular space, the empty room.

The grids that represent tiles will guide placement of the kitchen cabinets. To draw the floor tiles, divide the base of the drawing into equal parts and use straight lines to unite each of your dividing points with the vanishing point.

Fig. 191. This interior rendering is executed in perfect parallel perspective. All the furnishings that will fill the space have been omitted to give you an uncluttered look at the box-shaped structure of the room, with its horizon line ruled in red.

191

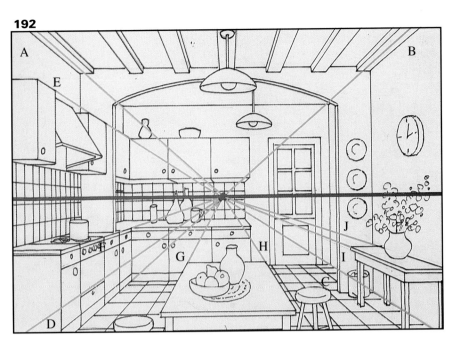

192

Leon Battista Alberti, the draftsman who created this exercise, uses the tile floor to establish relative positions of all the built-in cabinetry, kitchen appliances, and freestanding furnishings. For example, note that the small table on the right is three tiles high, and the stovetop is five tiles wide and five high.

To guide the placement of all objects in the room, Leon rules his vanishing lines E, F, G, H, I, J (fig. 192). These lines guide the drawing of foreshortened pieces, such as the table in the foreground.

Once all the furnishings are drawn in, the guidelines are erased (fig. 193), and with a #8 brush, Leon paints an absolutely uniform ochre wash on the far wall of the kitchen.

Fig. 192. Now all the cabinets, appliances, and other fittings have been added. The guidelines illustrating one-point perspective are explained in the accompanying text.

Fig. 193. Now we can begin to paint, applying uniform washes with clean, light colors.

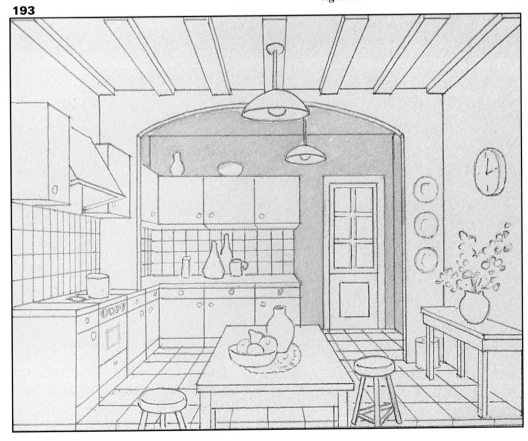

193

Additional uniform washes of ochre and pale browns are used to cover the walls, ceiling, and floor (fig. 184), leaving the cabinetry, accessories, and other objects unpainted for now. With the wash on the floor still wet, some white spaces are opened in it to simulate sheen on the tiles.

Different values of a sepia and yellow ochre mixture are applied to the cabinets, door, appliances, and freestanding furniture pieces (fig. 195). As in the previous step, window panes, light fixtures, stove hood, small equipment, and decorative objects remain white.

In the last step, modeling and volume are brought to the picture on the facing page (fig. 196). Once the paint is dry, a second wash is applied, this time in darker values to describe the ceiling beams, shadowed sides of cabinets and other furnishings. Since the light source emanates through windows in the door, that is taken into account in determining how shadows fall. These final washes should be uniform except when the volume of the object itself requires some variation. For example, in the case of the stools and the hanging light fixtures, a specific gradation in tone is painted to convey the effects of light and shadow on a curve.

Finally, colorful accents are added to the otherwise neutral palette by painting the vase and flowers, bowl of fruit, decorative plates, and ceramic jugs.

194

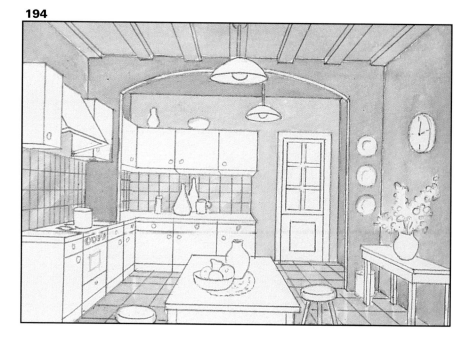

195

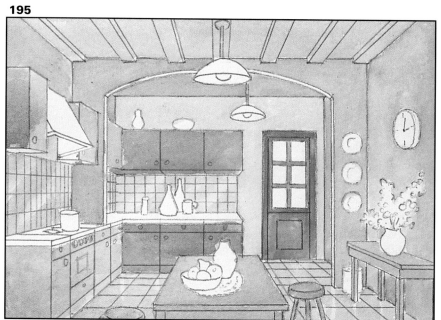

TIPS

When you draw the walls, ceiling, and floor, keep in mind that the height of the ceiling has to be calculated in proportion to the surface area of the floor and in relation to the level of the horizon line.

In one-point perspective, points on geometric shapes are drawn toward the point on the horizon line.

Figs. 194–195. We continue to refine the painting with uniform washes, first covering structural and built-in features of the room, then toning the freestanding furniture pieces.

196

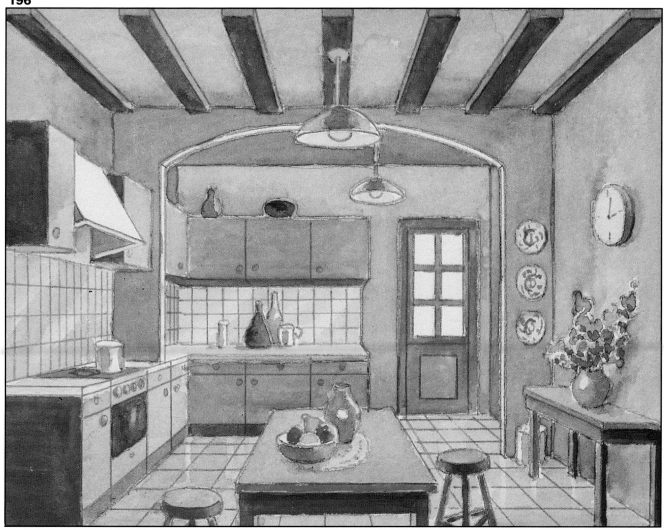

Painting interior scenes in watercolor requires practice with perspective, which this exercise certainly provides. Once you've worked with this exercise and decide to use a room in your own home as subject matter, don't make the mistake of illuminating it with artificial light, which is often in the center of a room and may disperse cast shadows of various lengths in different directions, complicating things for you. Instead, try to choose a room with a single source of light, preferably natural light, entering from one direction.

Fig. 196. This final painting of an interior in one-point perspective can be used as a reference model for depicting rooms in your own home.

An Interior in Two-Point Perspective

After completing an interior in one-point perspective, it shouldn't be difficult for you to tackle another room setting, this time in oblique, or two-point, perspective, based on two vanishing points. Use pattern number 5 for this exercise.

At first glance this may seem more challenging, but if you follow my step-by-step instructions, you'll soon discover that it isn't. As in the previous exercise, on a drawing of the room's basic structure, we start by ruling in the horizon line (fig. 197). This time, vanishing points will be outside the painting, one on each side, just above the horizon line. Note that the box representing the unfurnished room looks like a cube from which two sides have been removed so that we can peek inside.

Fig. 197. This box representing an empty room is seen in parallel perspective from a slightly elevated point of view.

197

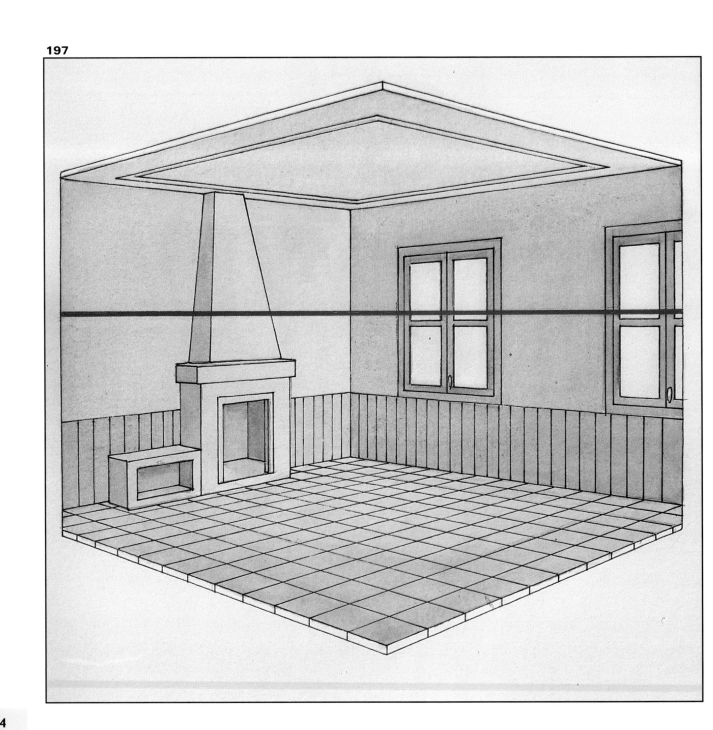

198

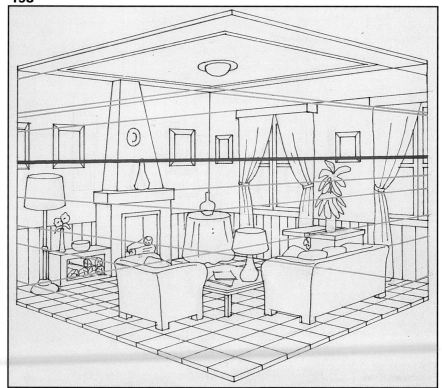

To furnish this room, we begin as in the previous exercise by placing each object in relation to the grid on the floor, starting with furniture against the wall and ending with pieces in the center of the room (fig. 198). Once we've marked the location of each object, we project diagonal lines that unite the vanishing points with each of the objects.

After placing each object by calculating its dimensions and proportions, we complete the drawing freehand (fig. 199). Now we begin painting the walls with a uniform wash.

Fig. 198. All the furnishings are drawn in, guided by two-point perspective lines, as described in the accompanying text.

Fig. 199. Flat areas are painted with uniform, monochromatic washes.

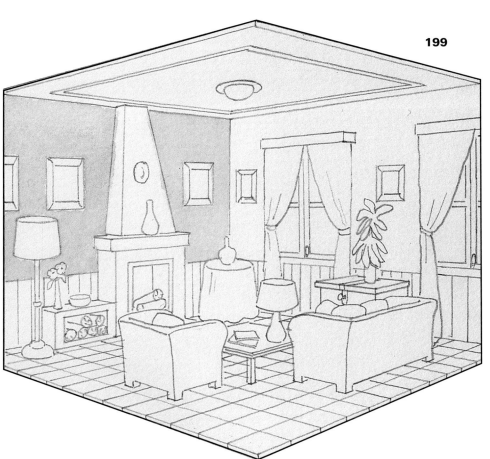

199

Before painting the floor, it's important to establish the source of light entering the room. This factor determines how shadows and highlights fall on the tile floor, which is painted pale gray with a dry brush on wet paper (fig. 200). Note how shadows cast by furniture on the tile give the whole image a more realistic look.

After all the flat washes have been applied, we paint in contrasting values here and there to impart volume to some of the structural forms (fig. 201), then paint graded blue washes on the sofa and chair and add touches of different colors for pillows, the corner tablecloth, and other ornamental accents.

Fig. 200. This is the moment to decide where the source of the light is, and to establish shadows and highlights in order to bring more realism to the work.

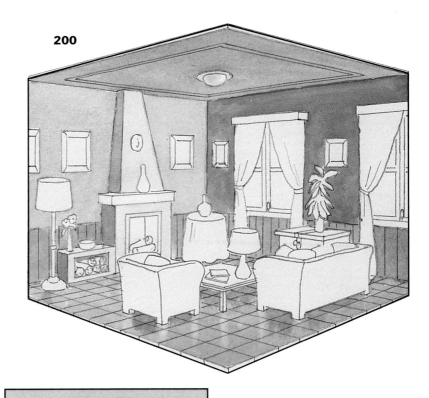

200

TIPS

When painting shadows in an interior scene, remember that they must be in correct perspective, as are all other elements in the picture.

Fig. 201. Once the flat shapes are resolved, we paint the furniture, adding shadows and highlights to create a sense of volume.

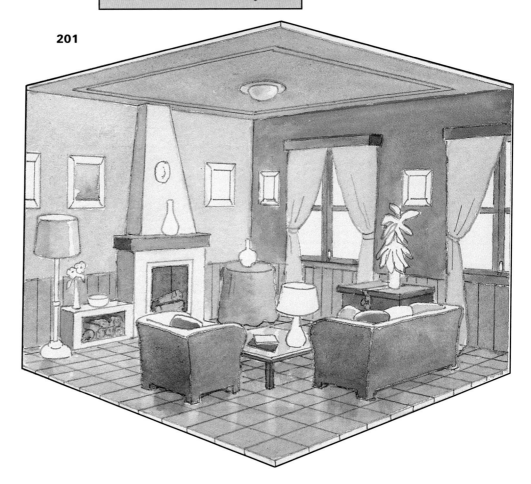

201

Getting back to the basic drawing that underlies this exercise, everything about the living room depicted boils down to seeing geometric forms from an oblique point of view. With two-point perspective such as this, you may have a problem dealing with vanishing points located outside your painting, which makes it more difficult to find the correct slope of lines that define furniture, walls, windows, and so on. One way to solve this problem is by placing a larger sheet of paper under your drawing, so that despite being outside of the plane of the painting, the vanishing points will be visible on the extended paper underneath. For a more graphic description of this process, review "The Basics of Perspective" detailed on page 30.

Fig. 202. Use the drawing that this exercise is based on as an example in practicing the basic forms that may be present in any interior rendered in two-point perspective.

Variety Within Unity in a Still Life

A valuable piece of advice that I quoted earlier bears repeating. It's Plato's succinct definition of the art of composition: "variety within unity." When painting a still life in watercolor, this means finding objects that harmonize with one another without being too repetitious, then arranging them in a way that engages the viewer's eye as it travels from place to place within a balanced, yet lively, composition.

Merche Gaspar meets that challenge admirably in this exercise, showing us how the color, shape, and texture of her chosen objects bring variety and unity to her vibrant watercolor painting. She reached her goal through trial and error, arranging and then rearranging objects until she found just the right composition for them.

The first step in composing a still life is establishing a center of interest, in this case, a vase holding a casual arrangement of tulips. From there on, the placement of all other objects must revolve around that central focal point.

Fig. 203. Merche Gaspar makes a first attempt at putting together a still life. She places a bowl of fruit right in front of a vase filled with tulips, forming a solid of the two entities. After studying it for a moment, she decides that it's too tight and monotonous a composition. It may be perfect in terms of unity, but it's a disaster in terms of variety.

Fig. 204. The artist keeps trying. Now the placement of the objects couldn't be more varied. Individual pieces of fruit are scattered toward the bottom, and the flower vase and fruit bowl are now separated. But now these components are too far apart, too dispersed. In a composition like this one, the eye jumps from one point to another, not knowing where to focus.

Fig. 205. In her final composition, the artist solves all her problems. Now unity is achieved through a well-balanced arrangement of components. Variety is also addressed in the way distinctive fruits are distributed in the foreground, maximizing their individual qualities while achieving an overall cohesion and certain originality of design composition.

203

204

205

206

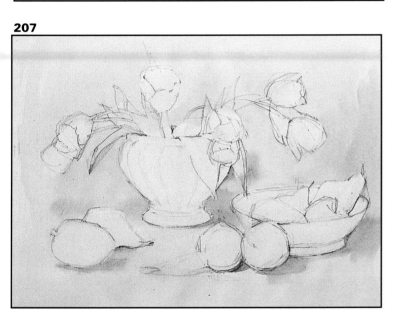

Once the center of interest has been established and an appealing variety within unity is seen in the final sketch that places all objects in a cohesive composition, it's time to start painting.

Fig. 206. With a 2B pencil, Merche draws on watercolor paper attached to a rigid support. The still life is directly opposite her, and her board is tilted a few degrees and supported on her lap.
Fig. 207. The artist's first concern is to do away with the whiteness of the paper, which she does by covering the background with a very diluted ochre wash. Then she adds Payne's gray to the wash to indicate shadows cast by the objects.
Fig. 208. She starts to paint the tulips and peaches alla prima, applying colors with their respective tones and shades all at once onto the wet paper. Her aim is to get the volume and shapes right from the start.
Fig. 209. As she moves along, Merche paints the pears a pale wash of permanent green mixed with carmine. The tones of the mix are applied in such a way that they suggest relief and volume right from the beginning.

207

209

208

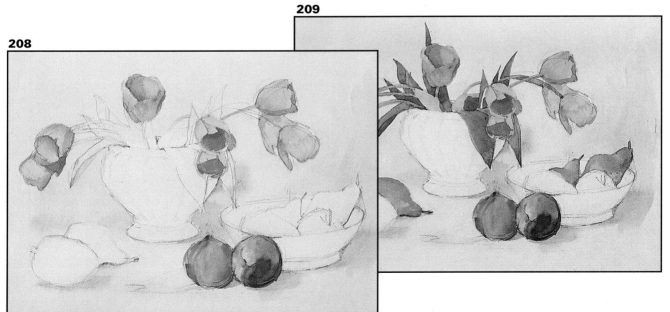

Fig. 210. This step shows Merche skillfully portraying the metal bowl. Before starting to put in any highlights, she covers the white paper with a grayish wash. Then working very quickly, she paints the fruit bowl with a slightly darker gray diluted further with water, leaving the areas suggesting highlights unpainted. Then she depicts cast shadows made by the fruit in front of the bowl with another, slightly darker wash.

Fig. 211. Most of the essential components are now developed: the fruit, the flowers, and some shading. Using a palette of many colors, the painter has taken into account the similarity between some of the fruit colors, such as a pear and a mango in the metal bowl, and how to distinguish them. She does so by giving subtly different nuances to tones that in reality are very similar but must be painted in a way that clearly differentiates them.

Fig. 212. Merche abandons the fruit for the moment and works on the ceramic vase, which presents challenges of its own. First she applies a very diluted wash of earth tones. While this wash is still wet, with a #12 brush dipped in a darker value of the same mixture, she paints curved, vertical strokes from top to bottom to describe deep grooves all around the vase.

210

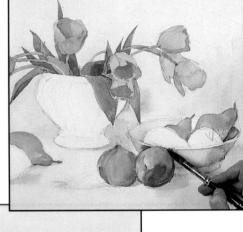

211

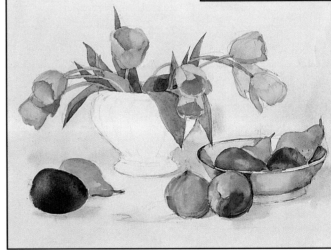

212

Fig. 213. Once the previous wash has dried, with a slightly smaller brush dipped in a mixture of dark yellow and carmine, Merche paints the reddish tint to simulate a metallic-like sheen on the vase, then adds white highlights using a wax pencil.

213

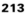

TIPS

All great masters throughout art history have shown variety within unity in their work. In still life, as with other subject matter, their compositions begin with simple geometric forms.

The freedom exercised in composing a still life also extends to color choices. Keep in mind that it's just as possible to select objects for their colors as it is to base choices on the shape and size of objects.

214

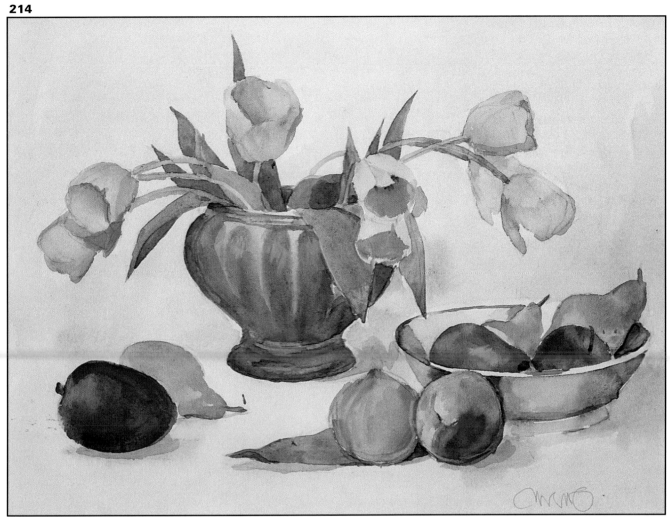

Fig. 214. Excellent composition and chromatic harmony produced this fine watercolor painting by Merche Gaspar.

If you're a beginner with watercolors, in preparation for painting still lifes like this one, it would be a good idea to practice painting individual pieces of fruits and various kinds of flowers, before combining them in a unified composition. Small studies of fruits and flowers painted and saved in a watercolor book will serve you well as valuable reference material for finished watercolor paintings later on.

Also study the still lifes of great painters through history to see how they have handled complex arrangements of fruits, flowers, vases, bowls, and other components common to the genre.

Accentuating Landscape Planes

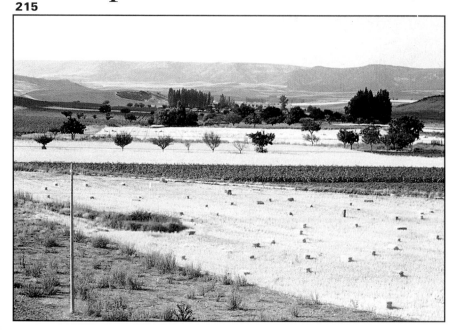

I was driving through the province of Cuenca, in central Spain, coming from a little town in which I had started a painting the day before, when, from a somewhat elevated highway, I looked down on one of those great plains of the region known as Castilla–La Mancha. Through my car window I saw a grand panorama (fig. 215): fields of grain, harvested hay in bales of different sizes against a background of abundant vegetation, and an expanse of green grass, cypress, and other trees framed by distant, bluish mountains.

This was surely a wonderful theme for a watercolor painting, which I initially saw in a horizontal format, the most conventional mode for a landscape composition.

But the next day, when I returned to enjoy the scene again, as I studied it I wondered what it would look like if I were at a higher elevation, where I could see almost all of it from a bird's-eye view. So I gave up the idea of a horizontal composition, took out my paper and pencil, and started to draw in a vertical format, imagining more space between one plane and another and accentuating the stand of cypress and other trees. This interpretation differed considerably from the reality before me, as you can see from my drawing (fig. 216).

As I continue with this exercise, join me by using pattern number 6.

First I paint the sky, using a very diluted carmine (fig. 217). Continuing to change and reinterpret what I see, I use the same carmine to paint a gradation in tone from the base of the mountains upward. Next, I paint the mountains in the background in a violet blue that is darker than the light blue of the scene before me (fig. 218).

216

Figs. 215–216. Many aspects of this expansive landscape make it ideal subject matter for a watercolor painting.

My pencil drawing begins, as usual, with horizontal and vertical dividing lines to make the calculation of dimensions and proportions easier.
Fig. 217. I paint the sky with a very diluted carmine wash, using a gradation in tone that extends from the base of the mountains to the edge of the paper.
Fig. 218. On the mountain range, I apply a thin glaze of violet blue. Its transparency allows the previous layer of diluted carmine to show through here and there.

217

218

219

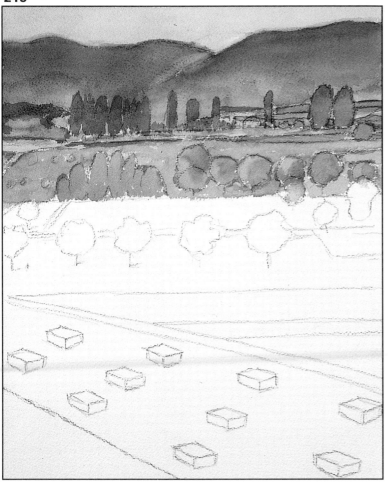

I start on the range of greens of the cypresses and other trees, using a light, slightly bluish green wash (fig. 219). With a pale ochre wash, I paint in a field near the trees. At this early stage, my aim is to cover the white paper with similar-value washes to avoid inadvertently producing simultaneous contrasts. So I continue filling spaces without introducing too many value contrasts, trying to achieve harmony in a minor key.

All major spaces are filled with colors that are fairly light now (fig. 220), but they work together to maintain a harmonious overall effect.

Making use of the play of light and shadow through dark and light tonal gradations (fig. 221). I model the cypresses, the vegetation, and trees in the background.

Fig. 219. Using a light bluish green mixture, I paint the stand of tall trees in the distance, coming forward with yellow greens toward the fields in the middle ground.
Figs. 220–221. I continue by painting the middle ground with green and earth tones, using a glaze that breaks up the white space, while preserving some it from the bales of hay. I also model the tall trees and other vegetation.

220

221

Now I concentrate on the line of trees closer to the viewer, putting blotches in the wheatfield in the middle distance and then giving shape to areas with darker shadows (fig. 222). As you can see, I also use a fairly diluted color to paint shadows projected by the trees.

Next, I work on the group of cultivated fields in the foreground, using a brush more heavily loaded with color to paint some indefinite shapes representing grass on top of the previous wash (fig. 223). I also paint a narrow strip of darker green to indicate the height of the grass.

The painting is almost finished now. My last touches occur (see facing page) when I apply color to the hay bales, paint their cast shadows, and add my signature (fig. 224).

222

Fig. 222. Now the foliage in the middle ground is developed as I dab on little blotches of color and then shape each into a tree.
Fig. 223. Working on the foreground, I give more definition to the cultivated green fields.

223

224

Fig. 224. In my final step, as shown in the completed painting, I describe each bale of hay and its cast shadows, and also add tone and texturing to the foreground field.

To summarize this exercise, when you get ready to paint a watercolor landscape, there are three basic factors to consider. My completed painting on this page should serve as your guide.

First, the choice of theme: Compose most objects and their shapes as prearranged by nature into a harmonious whole, but feel free to add, subtract, or rearrange some elements.

Second, the colors: Think about whether your watercolor landscape uses colors similar to the ones nature uses; if you alter some, as I did, that's fine. But remember that areas farther away should be more bluish, based on a range of cool colors, which appear to recede. Foreground colors should be warmer ones, those that appear to advance toward the viewer.

Third, interpretation: For example, the way in which the sky is painted; it doesn't have to be blue; it might be gray, pink, or cream-colored. Another example of interpretation is the way I compressed my scene, moving from a horizontal format to a vertical one, which has accentuated the landscape planes. Compression also enabled me to fit in more elements than would have been possible in a conventional horizontal format.

I suggest that you take photographs of scenes in a horizontal format and try to interpret them in a vertical format, as I did for this exercise; then try just the reverse with other scenes, going from vertical to horizontal.

"Tonalist" Still Life with Broad Value Range

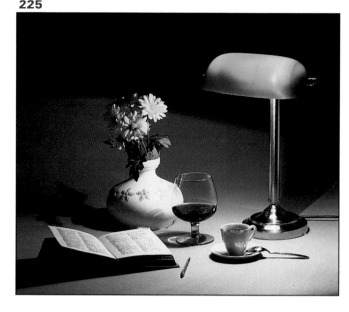

With the help of watercolorists Jordi Segú and Merche Gaspar, I'm going to illustrate the differences between what I call "tonalist" and "colorist" approaches to painting. The still life is the same for both exercises, although its look will be altered by the source of lighting employed.

With sidelighting on the still life in the first exercise, chiaroscuro, or a wide range of tonal values, will be evident in the painting; when frontal lighting is used in the second lesson, the interpretation is based on flatter color. These exercises are meant to increase your understanding of both methods.

Focusing our attention on the first exercise in question, the photograph immediately reveals a broad range of tonal values in the way the still life is illuminated by bright sidelighting (fig. 225). In this case, the lamp in the still life itself casts light on the scene, strongly accentuating shadows and giving volume to the objects.

The artist's initial line drawing in pencil has absolutely no shading (fig. 226); his main concern is portraying the correct placement, outline, and size of each object in the composition.

Using a #12 brush, Jordi starts to cover the background with a mixture of ultramarine blue, burnt umber, and Payne's gray, diluted in a generous amount of water to make the colors spread irregularly in blotches of different tones (fig. 227). Now he introduces cast shadows, using a deeper value of the same mixture (fig. 228).

226

227

Fig. 225. The dramatic play of shadows above is caused by sidelighting. A colorful and varied assortment of shapes combine to inspire a watercolor painting.
Fig. 226. Jordi Segú's drawing simplifies each object while clearly defining its contours.
Fig. 227. A diluted wash of several colors forms a dark background, carefully painted around the objects. A large amount of water in the wash leads to blotching, which creates an interesting texture.
Fig. 228. While the wash is still wet, darker tone is picked up from the top area and used to create cast shadows in the foreground.

228

Painting on wet paper with a darkened value of the blend used for the background wash, the artist refines local and cast shadows in the brandy snifter, on and around the book, under the saucer, next to the vase, and so on (fig. 229). With a lemon yellow somewhat diluted in blue, burnt umber, and alizarin crimson, he makes a first attempt at painting the flowers in the vase, the brandy in the snifter, the edge of the book, and the pencil in the foreground.

Once he has put in some of the shadows on the flowers themselves, Jordi takes a clean #8 brush and starts painting their true colors, including a pure lemon yellow to help produce an aura of volume (fig. 230). He adjusts the highlights and shadows on and around the cup and teaspoon, little by little adjusting the color and tonality of the objects themselves.

229

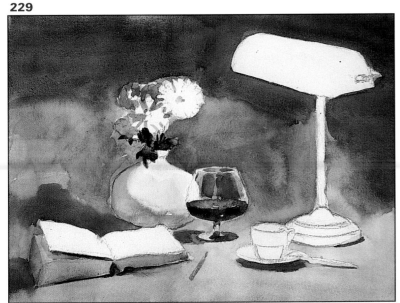

Fig. 229. As the artist incorporates his first notes of contrasting color, the flowers and brandy brighten up the background.
Fig. 230. Accentuating shadows and toning the flowers and cup and saucer gives them a sense of volume.

230

Now it's time to paint the lamp-shade. Using the #12 brush loaded with water and emerald and permanent green, he paints blotches of color, leaving white areas open, which are then covered with a lighter tonal value to produce highlights (fig. 231). Note that palest yellow tones of the flowers are also echoed in the lampshade.

To give more volume to the objects, the artist applies increasing gradations of tone (fig. 232), giving both the lamp base and the book a much more realistic appearance.

In this step, final touches are added, strengthening the distribution of highlights and shadows throughout the painting.

231

TIPS

From the start of a painting, it's a good idea to reserve white spaces for highlights that you'll want to emphasize as a final step. Also take liberties in inventing contrasts to heighten a range of tonal values.

Painting successive layers of wash helps create the varied tones and shades of color that lend reality to a still life.

232

233

Figs. 231–233. In painting a work with a broad value range, the artist continues to reinforce contrasts and accentuate particular objects. Note detailing of the flowers, the addition of decorative motifs on the vase, and the careful portrayal of the book's pages.

234

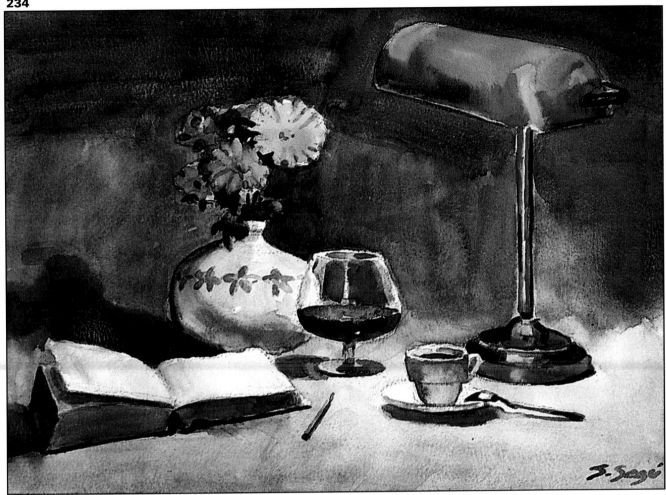

The final version of the watercolor by Jordi Segú (fig. 234) shows the rich range of tonal values that characterizes this painting technique.

In practicing this style, you may fall into a common beginner's trap: painting small sections or details right from the start, instead of letting yourself go and working on large washes with expansive brushstrokes. There's a sim-ple way to eliminate this classic pitfall from the beginning. Start by painting with a very large brush, such as a #20.

If you compare the final painting above with an earlier stage of it (fig. 230), you'll see that the differences lie mostly in the broadened range of tonal values that bring volume and a sense of reality to all objects in this handsome still life.

Fig. 234. The completed still life captures the essence of a strong interplay of light and shadow and its impact on bringing dimension and volume to a colorful array of objects.

"Colorist" Still Life Minimizes Tonal Values

235

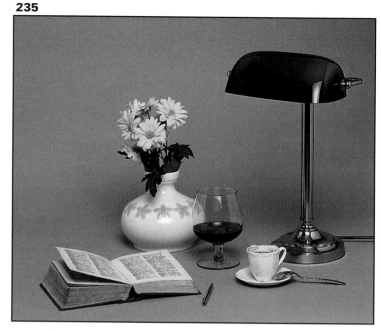

For this exercise, our subject matter is identical to the previous lesson but the look is substantially different due to the way light falls on the objects (fig. 235). With front lighting, the still life has very few shadows and highlights, as opposed to the dramatic lights and darks of the previous example. The volume of the objects is much less noticeable and their colors seem flatter and more concentrated by minimizing chiaroscuro.

This second exercise demonstrates how brighter and flatter colors can establish bold contrasts in a painting. I've called upon the work of Merche Gaspar to illustrate the differences between this style and the previous one.

Merche starts, as Jordi did, by doing a line drawing with a 2B pencil (fig. 236). She uses fairly thick strokes to outline the objects in order to establish their basic structure, but leaves out all shadows. Next, using a #12 brush, the artist covers the background, silhouetting objects as was done in the previous exercise, but this time the wash is weaker, more diluted, and uniform (fig. 237). Because she's applying the color in such a diluted form, Merche has to keep her block of watercolor paper lying flat so that the wash doesn't run off.

Her next step is to paint wide, uniform washes of burnt umber on the edges of the book (fig. 238). She uses a very diluted Payne's gray for the china cup and brandy snifter and cobalt blue for the floral decoration on the vase.

236

Fig. 235. The still life used in the previous exercise is now illuminated by front lighting, which eliminates most shadows.
Fig. 236. This freely sketched outline of each object is Merche Gaspar's first step in this companion exercise to the previous one.

Fig. 237. A very diluted wash is applied to the background, worked around all objects, leaving them white.

237

238

Fig. 238. Light background washes are reinforced here and there in blotches. Using a very wet brush, Merche introduces pale tones on some objects, suggesting their contours very subtly.

Though her vision of this still life calls for flatter colors, leaving out gradations of tone and hue, Merche decides not to use intensely saturated hues or extremely exaggerated contrasts. So in her next step, her brushstrokes show some subtle variations as applied to the base of the lamp, the cover of the book, the base of the

brandy snifter, and the saucer and teaspoon (fig. 239).

Now she applies a diluted sepia to suggest the contents of the snifter, then paints the little bouquet of flowers. Once the previous wash on the snifter has dried, Merche dips her brush into a darker sepia blend, then shapes the bristles into a perfect point, and with a

few precise and skillful strokes, completes her description of the brandy (fig. 240).

239

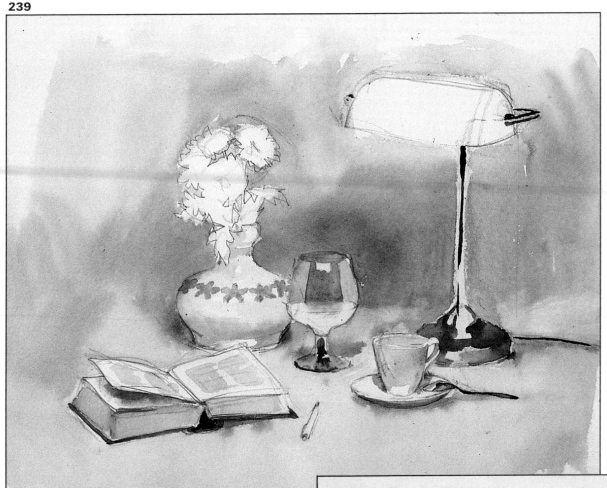

240

Fig. 239. Colors remain soft at this stage of the painting's development. Points of white highlight that will carry through to the completed work are established here on the lamp base and brandy snifter.
Fig. 240. As Merche begins to intensify selected colors, the deep crimson brandy makes a dramatic contrast to the white vase nearby.

The uniform tone of colors used to depict the flowers and leaves is adequate for hinting at their volume (fig. 241). This volume is intensified by the clear contrast between these colors and the background (fig. 242).

The only thing still needed to complete this exercise is finishing the lamp. Merche proceeds to fill this white space with a uniform mixture of Payne's gray and emerald green, applied so that a bit of white paper is left to represent a highlight on the lampshade (fig. 243). This color doesn't correspond exactly to the real color of the lamp, but rather with the artist's personal vision.

241

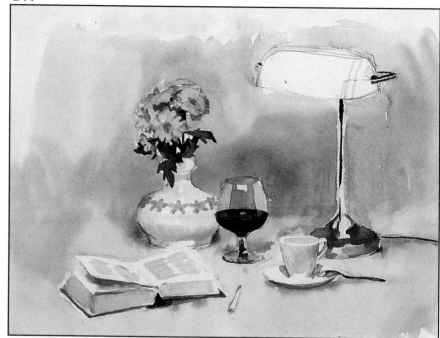

242

Fig. 241. Using sepia for the lamp base with vertical slivers of white on its stem effectively simulates the metallic glow of brass.

Fig. 242. Merche's brushstrokes are soft and uniform. She paints with one color, cleans the brush, applies another color, cleans the brush, and so on, until she completes her painting.

Fig. 243. Once her pencil lines are erased, Merche declares her painting completed.

243

TIPS

It's very important to paint with clean, bright colors. Rinse your brushes frequently and blot them on a paper towel.

Practice making quick preliminary sketches in color. This will prepare you for painting several watercolors, one after another, in a single session. Try varying the order and placement of colors in each sketch, and don't worry about your mistakes, since it's from them that you'll learn the most.

244

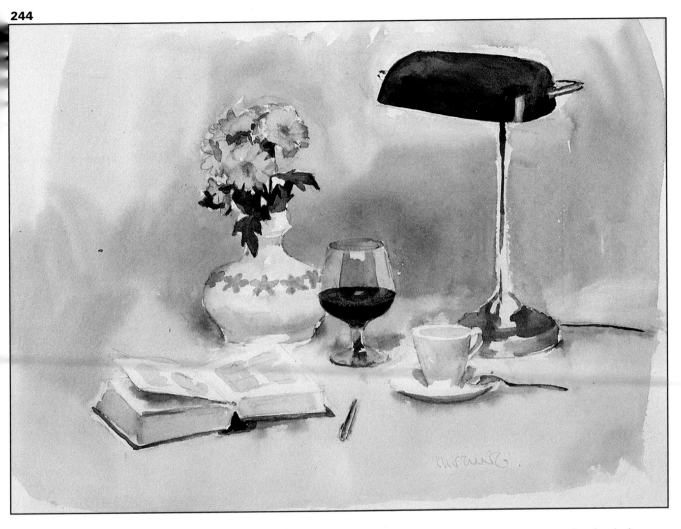

*Fig. 244. The completed painting,
with its absence of a range of hues,
tonal values, and deep shadows, has
a clean, fresh, and airy look.*

After looking at her finished painting (fig. 244) for a long while, Merche decided that it should stay the way it is. Hers is a watercolor executed with great confidence, a lively work in which the artist has deliberately left some areas unfinished, among them the lamp base, the cup and saucer, and an undefined foreground surface.

She has also used a weak wash to diminish the whiteness of the paper and simulate a luminous atmosphere appropriate to a composition that is illuminated from the front.

Before leaving this exercise, have another look at the original still life on page 90 and consider other possible interpretations that the objects and colors themselves suggest. How well you perform this exercise will depend on your capacity to imagine and see in the objects possible variations by using your option to omit, diminish, or substitute certain features.

Glossary

Alla prima: Term adopted from the Italian, referring to the technique of painting in a single session, quickly and without any retouching.

Asymmetry: Strictly speaking, a lack of exact correspondence in composition between the opposite halves of a painting on either side of an imaginary line dividing it. When in a drawing or painting the structure and distribution of the composition is intuitive and doesn't follow any rules, even while a balance of certain masses in relationship to others is maintained, we say that the work shows asymmetry.

Atmosphere: Landscapes and seascapes are sometimes said to "have atmosphere," especially when backlighted. "Atmosphere" comes about when the air between the foreground and the background is made up of layer upon layer of mist. As a consequence, the foreground stands out and the background loses color and is less defined.

Background: The area in a painting that seems to be farthest from the viewer; objects behind the middle ground and foreground.

Backlighting: Contrast produced when the light reaches subject matter from behind, thereby creating dark shadows against a luminous background.

Blocking in: Stating the basic pattern of a composition by drawing in its largest shapes, using simple geometric forms—cubes, spheres, cones, and cylinders.

Buckling: When paper becomes curved or warped as a result of being too wet, a condition that occurs more readily when the paper is thin.

Cast shadow: The shadow cast by one object onto something else in the picture, such as a vase casting its shadow on the table on which it sits.

Chiaroscuro: Italian for "light-dark"; in painting, the technique of modeling form by subtle gradations of light and dark tonal values.

Color, local: The color belonging to each object, when unaltered by shadows or highlights.

Color, reflected: Color that exists in all objects as the direct or indirect reflection of light and color projected by other objects.

Composition: The placement of various elements that make up the subject matter of a painting, the objective being to create a balanced, visually appealing, and harmonious arrangement.

Drybrush technique: A textured look produced by the scanty use of watercolor pigment on rough-textured paper, whereby the paint clings only to the raised fibers of the paper.

Ferrule: The metal collar on a brush handle that holds the bristles in place.

Foreground: The bottom of a painting, containing subject matter that appears to be closest to the viewer.

Format: The orientation of a painting: horizontal, vertical, or square.

Glaze: Coat of translucent color superimposed on another color to intensify or otherwise alter it.

Golden Section: Traditional proportions to achieve visual harmony, in which the ratio of the whole to the larger part is the same as the ratio of the larger part to the smaller.

Grain: The texture of a sheet of paper, determined by the distribution and degree of uniformity of the fibers in it. Rough-grained paper is the best for watercolor painting.

Line drawing: In preliminary sketches underlying a watercolor painting, the blocking in of subject matter with lines alone, free of tonal gradation, avoids having extensive pencil marks to mix with and muddy watercolor paint.

Middle ground: Midway between foreground and background.

Modeling: A term used in sculpture, it also applies to watercolor painting in describing the use of different tonal values to create the illusion of three dimensions.

Palette: A portable tray on which the artist sets out and mixes colors Watercolor palettes have separate box compartments for holding up to two-dozen different colors squeezed from tubes of watercolors. Sets of pan watercolors come with their own built-in palette inside the lid.

Pan watercolors, dry: Small, hard cakes of color over which a wet brush is run to extract color that is weak at best; inexpensive, low-quality watercolors best reserved for children's use.

Pan watercolors, semi-moist: Of high quality and wet enough to use with ease, they come in refillable sets with built-in palettes that are very compact and convenient for travel.

Perspective: The representation of three-dimensional space on a two-dimensional surface, so that depth and distance can be portrayed.

Pigment: The coloring agent in paint.

Sable brush: The best brush for watercolor, it has smooth, flexible hair that holds color well and is very resilient, always retains a good point; expensive but of high quality and long-lasting.

Scale: Proportion; something drawn "one-third" scale is drawn one third the size of the original.

Sketch: Preliminary drawing or painting on which a later, fully developed work may be based.

Texture: Tactile and visual quality presented by the surface of a watercolor painting through its brushstrokes and the grain of the paper, ranging from smooth application, where paper grain barely shows, to loose, dry-brush application on a coarse surface where the paper's grain is quite visible.

Tone: The prevailing hue in a painting and its comparative brightness or dullness.

Tonal value: The range of lights and darks within a single hue, and the range of lights and darks along the whole spectrum of hues, from the lightest, white, to the darkest, black.

Tube watercolors: A creamy, liquid paint that comes in small tubes that can be easily squeezed for filling compartments in a watercolor palette. The form of watercolor paint preferred by most professionals and other serious artists.

Utility knife: A sharp, pointed blade inserted in a handle, this versatile tool can be used to scrape color off of a dry watercolor painting to introduce white highlights.

Value scale: A gradual range in tone, from lightest to darkest, with no brusque transition from one end of the spectrum to the other.

Wash: Color diluted with water and applied in a thin, transparent layer.

Permissions

The author wishes to thank the following for use of photographs.
(Works are listed in order of their appearance in the book.)

Landscape, T. Sayol. Collection of the Association of Watercolorists of Catalonia.

View of Windsor, Thomas Miles Richardson Jr. Royal Watercolours Society, London.

Aiguamolls, Traver Criñó. Collection of the Association of Watercolorists of Catalonia.

Saint Gothard Landscape, J. M. W. Turner. Abbot Hall Art Gallery of Kendal, Cumbria.

View of a Canal Near the Arsenal, J. M. W. Turner. Tate Gallery, London.

White Boats, John Singer Sargent. The Brooklyn Museum, New York.

Arveiron, F. Towne. Victoria & Albert Museum, London.

Jacob's Staircase, William Blake. National Gallery, London.

The Adams House, Edward Hopper. Roland P. Murdock Collection, Wichita Art Museum.

Provence Landscape, Paul Cézanne. Kunsthau, Zurich.

River Bed, John Singer Sargent. Royal Watercolours Society, London.

Bäume in Bazincourt, Camille Pissarro. Louvre, Paris.

Somerset Place, Bath, J. Piper. Tate Gallery, London.

Bodegón, Paul Cézanne. Louvre, Paris.

Umbrellas in the Rain, Maurice Prendergast. Museum of Fine Arts, Boston.

Coast of Maine, John Marin. Kennedy Galleries, New York.

Tahitian Landscape, Paul Gauguin. Louvre, Paris.

Tahitian Huts, Paul Gauguin. Louvre, Paris.

Street Scene, August Macke. Städtisches Museum, Mülheim.

Stonehenge, John Constable. Victoria & Albert Museum, London.

Sunflowers, Emil Nolde. Nolde-Stiftung, Neukirchen.

Courtyard of the Pilatos House in Sevilla, Marià Fortuny. Museo de Arte Moderno, Barcelona.

Acknowledgments

The author of this book is grateful to the following individuals and businesses for their collaboration on the publication of this volume in the Techniques and Exercises series. Thanks to Gabriel Martín Roig for his contributions to the text and for the general coordination of this book; to Antonio Oromí for photography; to Vicenç Piera of the Piera firm for his advice about tools and materials for painting and drawing; to Manel Ubeda of the Novais firm for the layout and design; and, most particularly, to the artists Merche Gaspar, Ester Llaudet, and Jordi Segú for providing illustrations and step-by-step exercises.